Shoes

Page 4:
Seducta shoe, 1954
International Shoe Museum, Romans

Designed by:
Baseline Co Ltd
19-25 Nguyen Hue
Bitexco Building, Floor 11
District 1, Ho Chi Minh City
Vietnam

ISBN 1-84013-734-7

© 2005, Confidential Concepts, worldwide, USA
© 2005, Sirrocco, London, UK (English Version)

© 2005 Joël Garnier

We would like to extend special thanks to the International Shoe Museum,
Romans, France, the Bally Museum, Schönenwerd, Switzerland,
Ledermuseum, Offenbach, Germany and the Ferragamo Museum,
Florence, Italy

Published in 2005 by Grange Books
an imprint of Grange Books Plc
The Grange Kingsnorth Industrial Estate
Hoo, nr Rochester, Kent ME3 9ND
www.grangebooks.co.uk

Printed in China

Foreword

"You never truly know someone until you have walked a mile
in his shoes."

— Anonymous

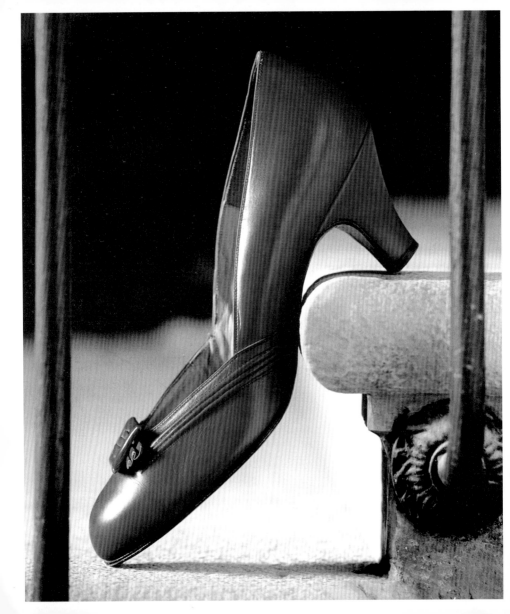

Contents

Sarah Navarro Robert Clergerie Stephane Kalian

Raymond Massaro Joseph Tchilinguirian

Patrick Cox

Sarkis Der Balian

Camille Di Mauro

Hellstern

Seducta

Roger Vivier

Charles Yantorny

Francois Villon

Charles Jourdan

Andrea Pfister Salvatore Ferragamo

Joseph Fenestrier Alfred Argence

Berluti

Julienne

A side from noticing a shoe for its comfort or elegance, contemporaries rarely take interest in this necessary object of daily life. However, the shoe is considerable in the history of civilization and art.

In losing contact with nature, we have lost sight of the shoe's profound significance. In recapturing this contact, in particular through sports, we begin its rediscovery.

Wooden sandal inlayed with gold,
treasure of Tutankhamen

18th Dynasty
Thebes, Cairo Museum, Cairo

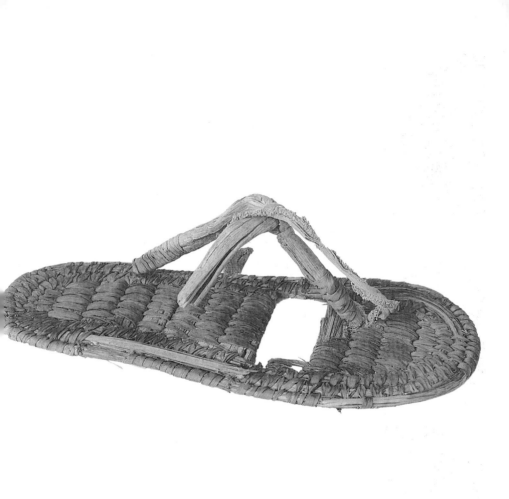

Shoes for skiing, hiking, hunting, football, tennis or horse-riding are carefully chosen, indispensable tools as well as revealing signs of occupation or taste.

In previous centuries, when people depended more on the climate, vegetation and condition of the soil, while most jobs involved physical labor, the shoe held an importance for everyone which today it holds for very few.

Egyptian sandal made of plant fibers

Bally Museum, Schönenwerd, Switzerland

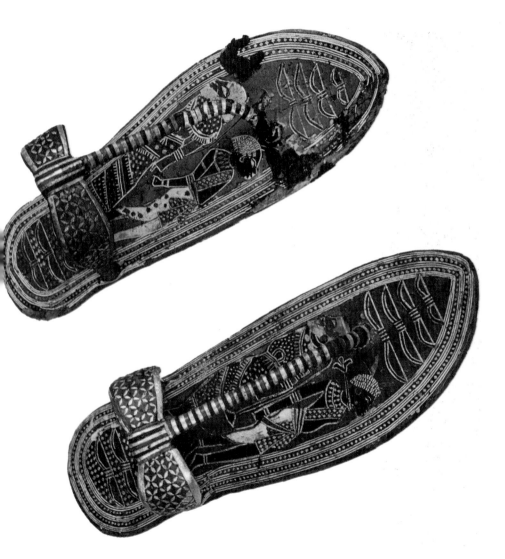

We do not wear the same shoes in snow as in the tropics, in the forest as in the steppe, in the swamps as in the mountains or when working, hunting or fishing. For this reason, shoes give precious indications of habitats and modes of life. In strongly hierarchical societies, organized by castes or orders, clothing was determinant.

Sandals

———

Found in the fortress of Massada

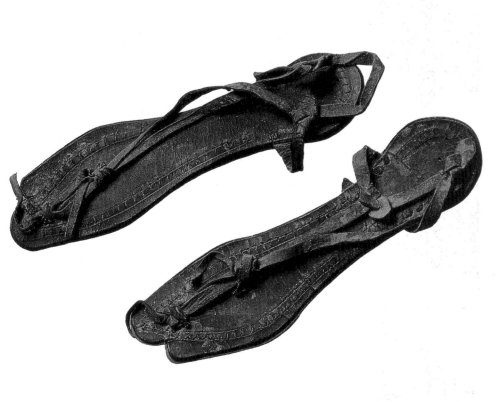

Princesses, bourgeoisie, soldiers, clergy and servants were differentiated by what they wore. The shoe revealed, less spectacularly than the hat, but in a more demanding way, the respective brilliance of civilizations, unveiling the social classes and the subtlety of the race; a sign of recognition, just as the ring slips only on to the most slender finger, the "glass slipper" will not fit but the most delicate of beauties.

Iron shoe

Syria, 800 BC
Bally Museum, Schönenwerd, Switzerland

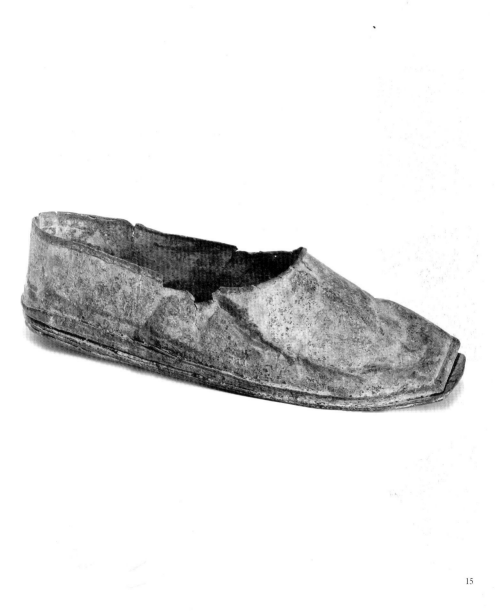

The shoe transmits its message to us by the customs which impose and condition it. It teaches us of the deformations that were forced on the feet of Chinese women and shows us how in India, by conserving the unusual boots, the nomadic horsemen of the North attained their sovereignty over the Indian continent; we learn that ice-skates evoke the Hammans while babouches suggest the Islamic interdiction to enter holy places with covered feet.

Silver sandal

Byzantine period
Bally Museum, Schönenwerd, Switzerland

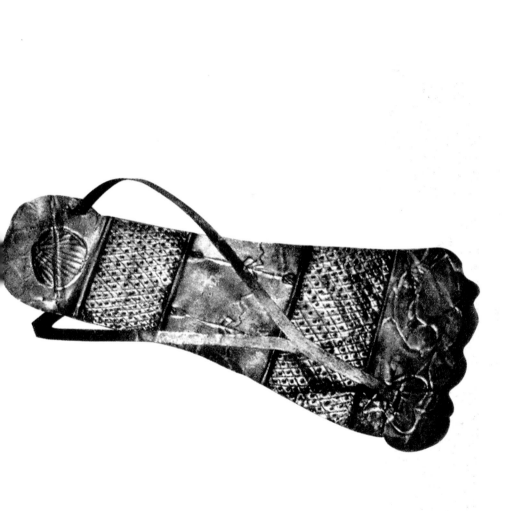

Sometimes the shoe is symbolic, evoked in ritual or tied to a crucial moment of existence. One tells of the purpose high-heels served: to make the woman taller on her wedding night in order to remind her that it is the only moment when she will dominate her husband.

The boots of the Shaman were decorated with animal skins and bones in order to emulate the stag; as the stag, he could run in the world of spirits.

Man's slipper

Vamp decorated with motifs gilded with gold leaf
Egypt, Coptic era
International Shoe Museum, Romans

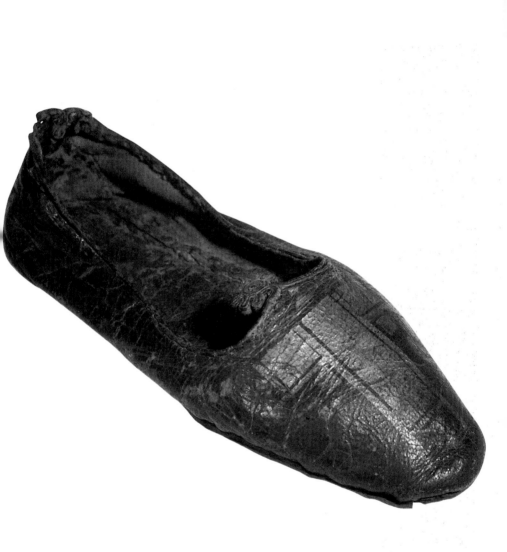

19

We are what we wear, so if to ascend to a higher life it is necessary to ornate the head, if it becomes an issue of ease of movement, it is the feet that are suited for adornment. Athena had shoes of gold, for Hermes, it was heels. Perseus, in search of flight, went to the nymphs to find winged sandals.

Liturgical shoe
of plain embroidered samite

Spain, 12th century
Silk and gold thread
Textile Museum, Lyon

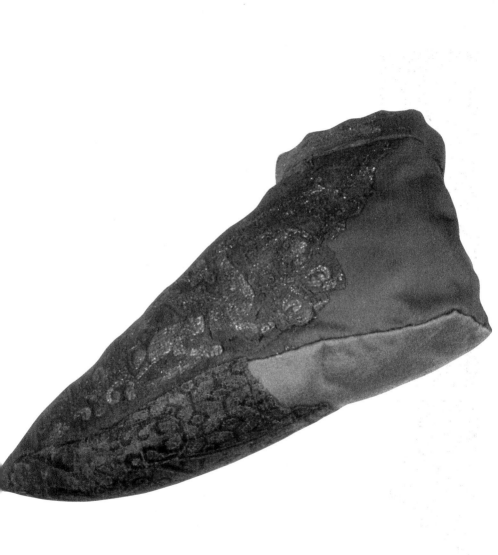

Tales respond to mythology. The seven-league boots, which enlarged or shrank to fit the ogre or Tom Thumb, allowed them both to run across the universe. "You have only to make me a pair of boots," said Puss in Boots to his master, "and you will see that you are not so badly dealt as you believe."

Poulaine style shoe

Bally Museum, Schönenwerd, Switzerland

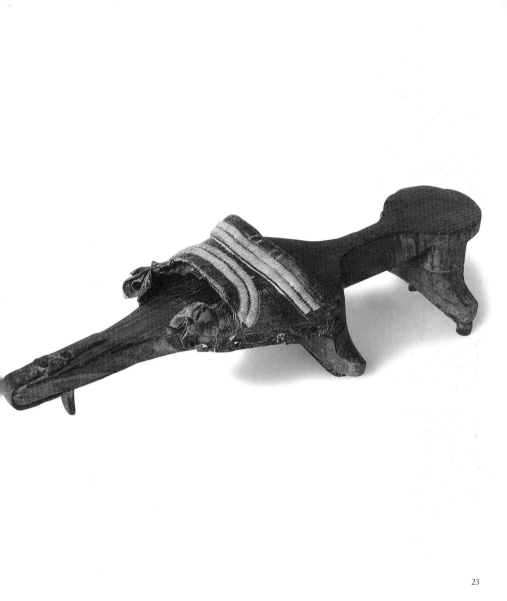

Does the shoe therefore serve to transcend the foot, often considered as the most modest and least favored part of the human body? Occasionally, without a doubt, but not always. The barefoot is not always deprived of the sacred and, thus, can communicate this to the shoe. Those who supplicate or venerate the shoe are constantly throwing themselves at the feet of men; it is the feet of men who leave a trace on humid or dusty ground, often the only witness to their passage.

Poulaine
———
Bally Museum, Schönenwerd, Switzerland

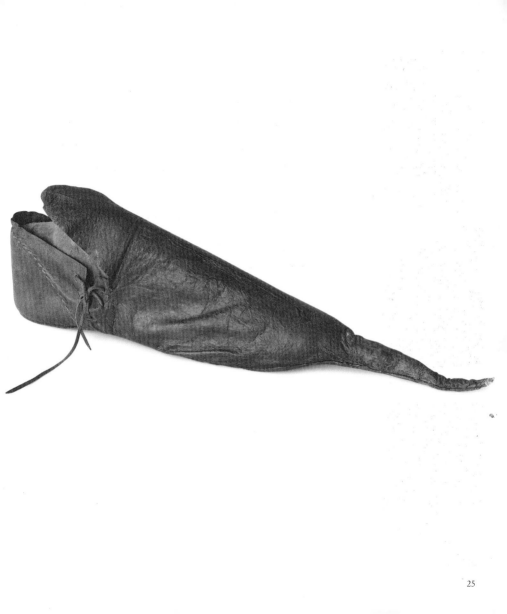

A specific accessory, the shoe can sometimes serve to represent he who has worn it, who has disappeared, of whom we do not dare to retrace the traits; the most characteristic example is offered by primitive Buddhism evoking the image of its founder by a seat or by a footprint.

Man's shoe in black distressed leather
upturned pointed toe, studded soul, claw heel

Persia, 15th-16th-century
International Shoe Museum, Romans

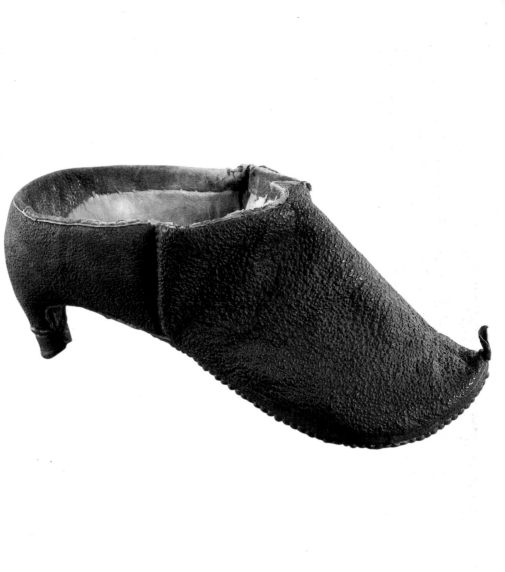

Made of the most diverse materials, from leather to wood, from fabric to straw, or whether naked or ornamented, the shoe, by its form and decoration, becomes an object of art. If the form is sometimes more functional than esthetic, the design of the cloth, the broidery, the incrustations, the choice of colors, always closely reveal the artistic characteristics of their native country.

Chopine

————

Venice, 16th century
International Shoe Museum, Romans

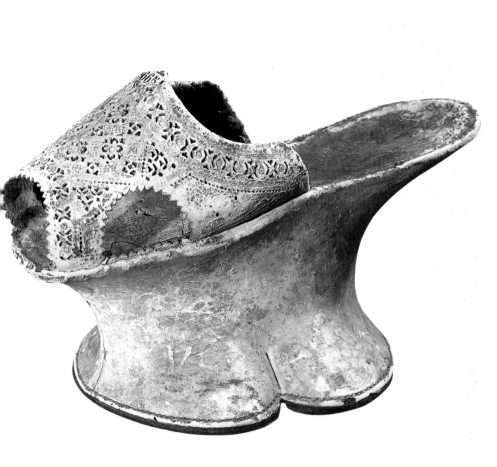

The essential interest comes from that which it is not; weapons or musical instruments are reserved for a caste or a determined social group, carpets are the products of only one or two civilizations, it does not stand up as a "sumptuous" object of the rich classes or a folkloric object of the poor.

Woman's shoe

Henri III period, France, 16th century
International Shoe Museum, Romans

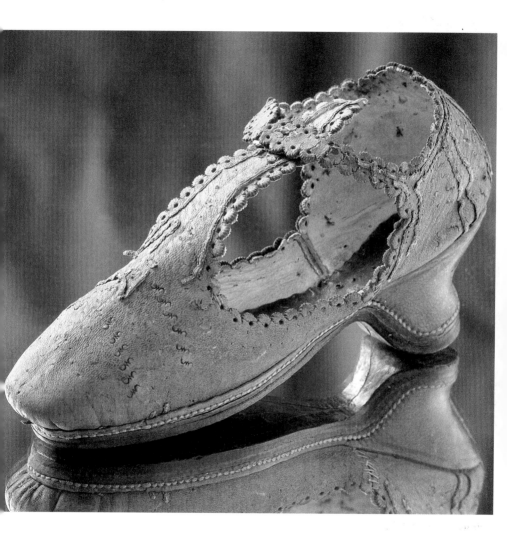

The shoe has been used from the bottom to the top of the social ladder, by all the individuals of any given group, from group to group, by the entire world.

It seems that man has always instinctively covered his feet to get about, although there remains no concrete evidence of the shoes themselves.

Woman's shoe

Italy, 17th-century
International Shoe Museum, Romans

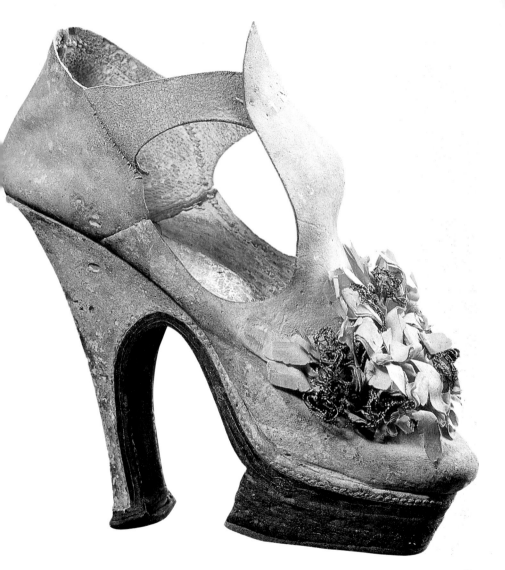

Prehistoric shoes would have been rough in design and certainly utilitarian in function. The materials were chosen primarily for their ability to shield the feet from severe conditions. It was only in Antiquity that the shoe would acquire an aesthetic and decorative dimension, becoming a true indicator of social status.

Musketeer boot

France, 17th century
International Shoe Museum, Romans

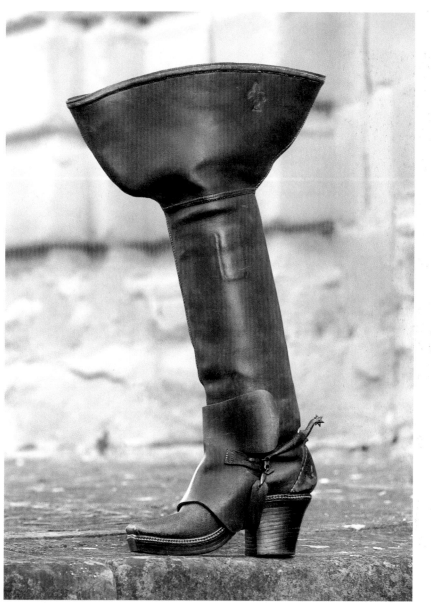

From the first great civilizations flourishing in Mesopotamia and Egypt in the 4th millennium BC arose also the three basic types of footwear: the shoe, the boot, and the sandal. An archeological team excavating a temple in the city of Brak (Syria) in 1938 unearthed a clay shoe with a raised toe dating over 3,000 years before the birth of Christ.

Woman's shoe in blue leather
with decoration embroidered in silver

Italy, 17th century
International Shoe Museum, Romans, deposit of the Musée
National du Moyen Age, Thermes de Cluny, Paris

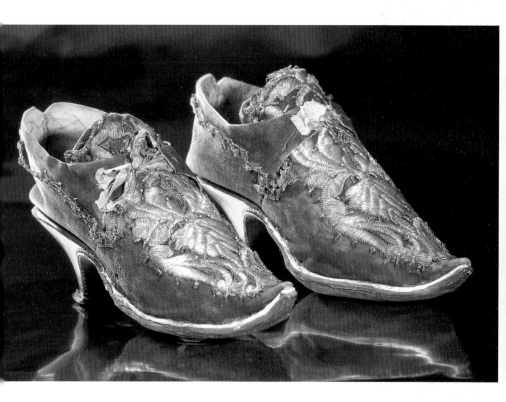

The raised-toe form is attributable to the rugged terrain of the mountain conquerors that introduced it. After its adoption by the Akkadian kingdom, the form spread to Middle East where the Hittites made it a part of their national costume. It is frequently depicted in bas-reliefs, such as the Yazilikaya sanctuary carvings dating to 1275 BC. Seafaring Phoenicians helped spread the pointed shoe to Cyprus, Mycenae, and Crete, where it appears on palace frescoes.

Woman's shoe with its protective clog

Louis XIV period, 17th century
International Shoe Museum, Romans, deposit of the Musée
National du Moyen Age, Thermes de Cluny, Paris

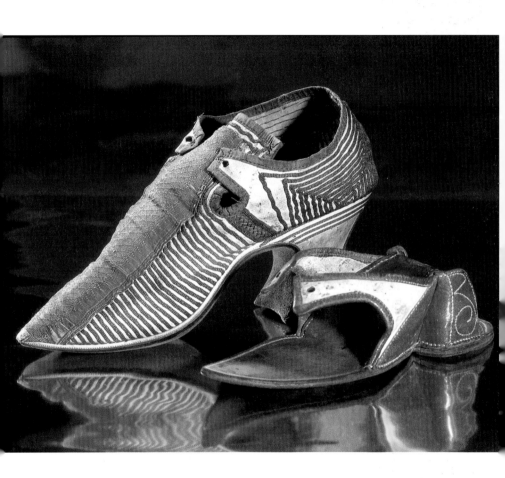

The Mesopotamian empire of Assyria dominated the ancient east from the 9th to the 7th century BC and erected monuments whose sculptures depict the sandal and the boot. Their sandal is a simplified shoe composed of a sole and straps. Their boot is tall, covering the leg; a type of footwear associated with horsemen.

Woman's shoe in damask embroidered with threads of gold and silver

Louis XIV period, 17th century
International Shoe Museum, Romans
Deposit of the Musée National du Moyen Age,
Thermes de Cluny, Paris

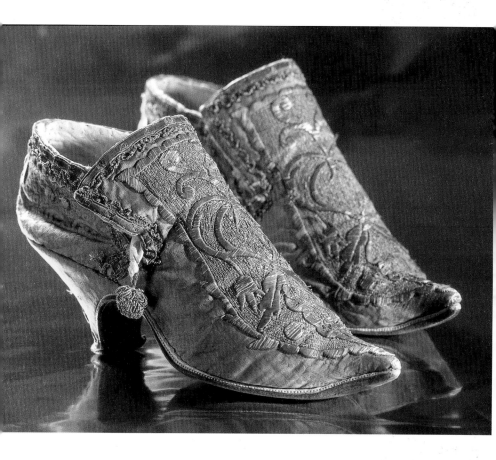

The Persian dynasty, founded by Cyrus the Great II around 550 BC, gradually established a homogeneous culture in the ancient east. Processional bas-reliefs carved by sculptors of the Achaemenidian kings offer a documentary record of the period's costume and footwear. In addition to images of boots, there are shoes made of supple materials and of leather shown completely covering the foot and closing at the ankle with laces.

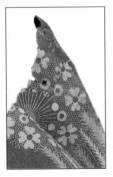

Rider's boot
Steel-tipped, claw heel

Persia, 17th century
International Shoe Museum, Romans

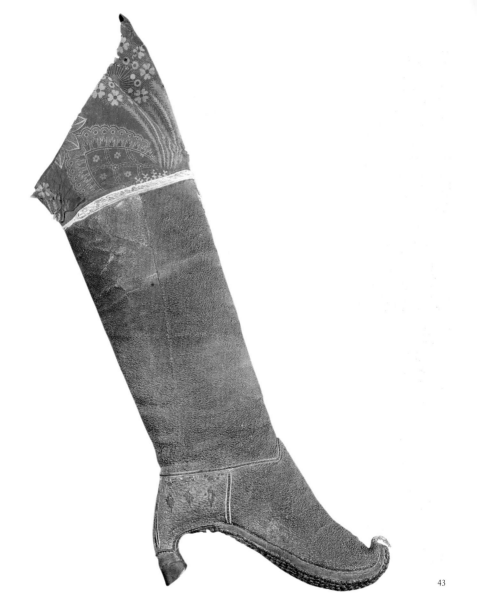

For a deeper understanding of how the shoe evolved from its origins to the present day, it is important to look at ancient civilizations in their historical context.

As in Egypt, the most popular shoe in Greece was the sandal. The Homeric heroes of *The Iliad* and *The Odyssey* wear sandals with bronze soles, while the gods wear sandals made of gold.

Shoe belonging to Henri II de Montmorency,
Leather decorated with a fleur de lis on the vamp
Initials of the duke on the flap

France, 17th century
International Shoe Museum, Romans, deposit of the Musée
National du Moyen Age, Thermes de Cluny, Paris

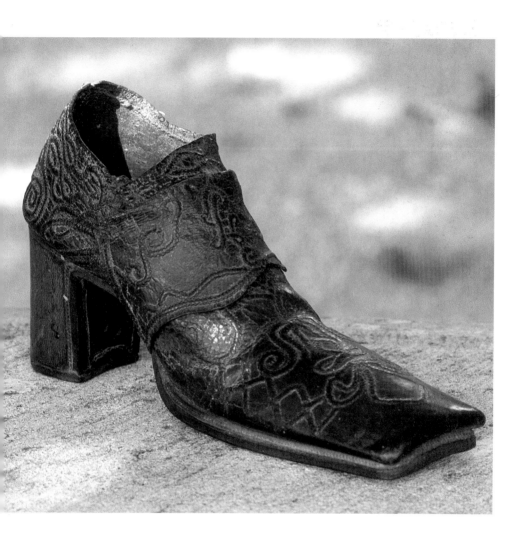

Agamemnon, legendary king of Mycenae, protected his legs with the help of leg armor fastened with silver hooks.

Rome was the direct heir to Greek civilization and felt its influence in the area of footwear: Roman shoes are mainly imitations of Greek models.

Postilion's boot also called, "seven league boot"

Weight: 4.5 kg. France, end of the 17th century
International Shoe Museum, Romans

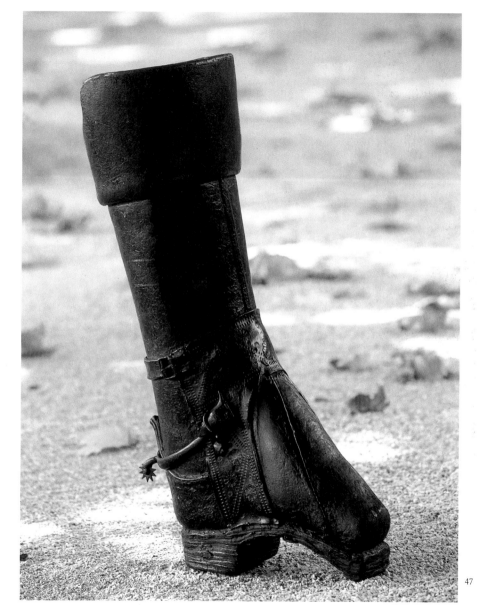

Byzantine civilization extended from the 5th to the 15th century, producing throughout this period a wealth of crimson leather shoes trimmed in gold reminiscent of embroidered Persian-style boots, as well as the Roman soccus and mulleus.

Byzantine mules and slippers were objects of luxury and refinement initially reserved for the Emperor and his court.

Shoe of the Marchioness of Pompadour (1721-1764)

International Shoe Museum, Romans,
depot of the Musée National du Moyen Age,
Thermes de Cluny, Paris

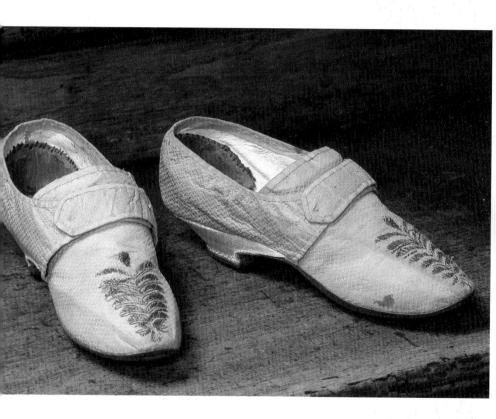

Crimson or gold slippers were worn in the eastern Mediterranean basin, in particular in the area around Alexandria and in the Nile valley. Excavations at Achmin have yielded many examples that belonged to women. The arrival of Christian shoemakers in this region revived the craft of shoemaking, as Christian symbols were added to the geometric decorative tradition.

Woman's mule

France, c. 1789
Guillen Collection, International Shoe Museum, Romans

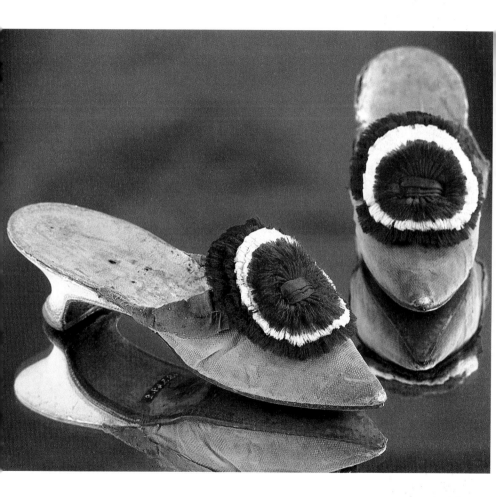

A silver sandal discovered in an Egyptian tomb and now in the collection of the Bally Museum is a good example. Dating to the 6th century AD, it is embellished with the image of a dove symbolizing Christ.

As the Middle Ages dawned in the West, footwear remained under the influence of ancient Roman models. The Franks wore shoes equipped with straps that rose to mid-thigh height. Only their leaders wore shoes with pointed tips.

Shoe of Marie-Antoinette
collected on the 10th August 1792

Carnavalet Museum, Paris

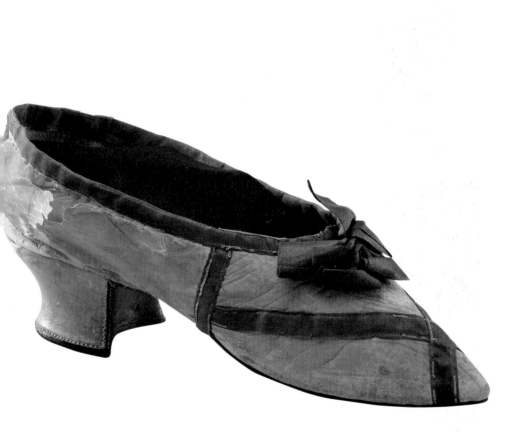

Thanks to the extraordinary degree of preservation of certain burials, we have an idea of what Merovingian shoes looked like. The tomb of Queen Arégonde, wife of King Clotaire I (497-561), discovered at Saint-Denis has enabled us to reconstruct an image of her shoes as made up of supple leather sandals with straps intertwining the leg.

Embroided mules

France, early 18th century

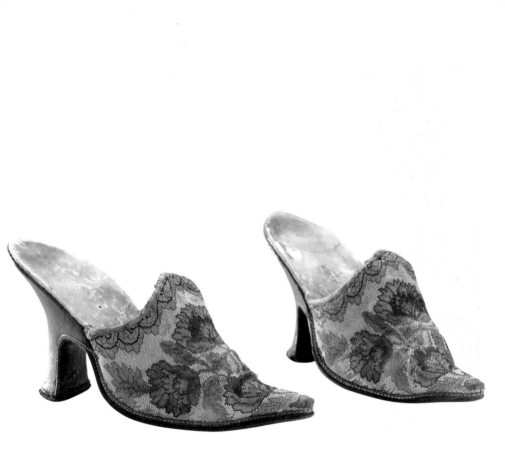

Elsewhere, gilded bronze shoe buckles decorated with stylized animals discovered in a leader's tomb at Hordaim, are proof of the attention given to shoe ornamentation during this period. Shoes were very costly during the Middle Ages, which is why they appear in wills and are among the donations made to monasteries.

Woman's shoe

Toe upturned in the eastern style
Louis XV period, France, 18th century
International Shoe Museum, Romans,
deposit of the Musée National du Moyen Age,
Thermes de Cluny, Paris

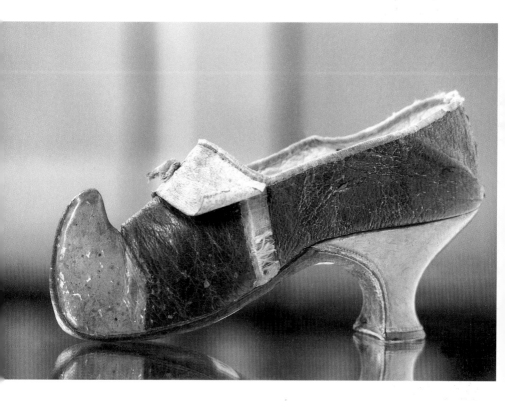

Expense also explains why a fiancé would offer his future wife a pair of embroidered shoes before marriage, a lovely tradition dating to Gregory of Tours (538-594). The strapped or banded shoe continued into the Carolingian period, although the woman's model became more embellished. As for the wooden-soled gallique or galoche, it too remained in use.

Woman's shoe

England, 18th century
Guillen Collection, International Shoe Museum, Romans

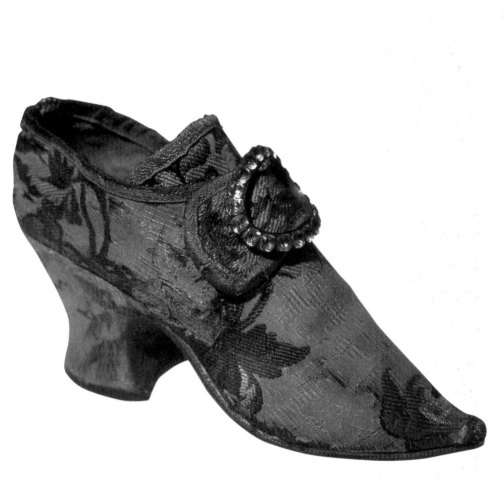

From this time forward, soldiers protected their legs with leather or metal leggings called "bamberges". In the 9th century, a shoe called the heuse made out of supple leather extending high on the leg announced the arrival of the boot.

Emperor Charlemagne wore simple boots with straps intertwining the legs, although for ceremonies he wore laced boots decorated with precious stones.

Carved, lacquered and painted wooden clogs

Louis XVI period, France, 18th century
International Shoe Museum, Romans, deposit of the Musée
National du Moyen Age, Thermes de Cluny, Paris

But frequent contact between France and Italy helped develop a taste for regalia and increasingly the shoe became an object of great luxury. At the same time, religious councils were ordering clerics to wear liturgical shoes while performing mass. Called sandals, these holy shoes were of cloth and completely covered the cleric's foot.

Clogs typical of the Bethmale Valley, Ariège

Gift from a fiancé to a younger woman;
apparently the higher the toe the stronger the love
18th century
Rural Museum of Popular Arts, Laduz, Yonne

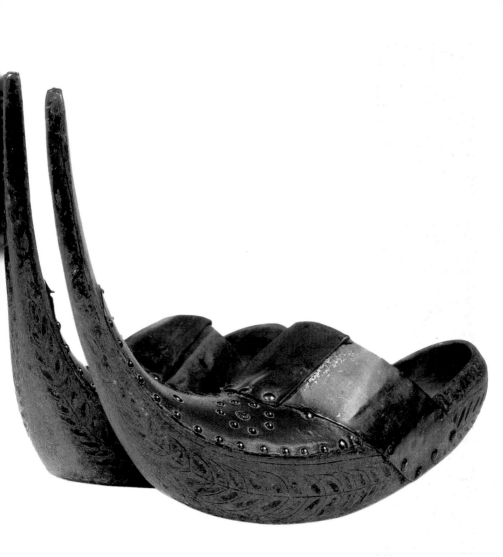

Regarding shoemaking, the French word cordouanier (which became cordonnier or shoemaker) was adopted in the 11th century and signified someone who worked with Cordoba leather and by extension, all kinds of leather. As in Antiquity, shoes were patterned separately for the right and left foot.

Clog-shaped snuffbox

Rural Museum of Popular Arts, Laduz

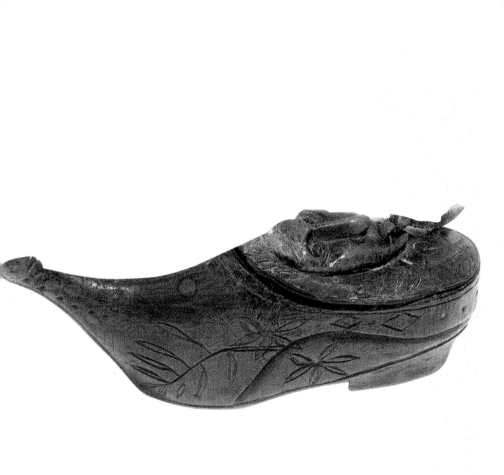

Shoes made out of Cordoba leather were reserved for the aristocracy, whereas those made by çavetiers, or cobblers (shoe repairmen) were more crudely fashioned. The wearing of shoes began to expand in the 11th century. The most common medieval type was an open shoe secured by a strap fitted with a buckle or button.

Clogs from the Bethmale Valley, Ariège

Wood, nail decoration in heart shape
Ariège, 18th-century
Guillen Collection

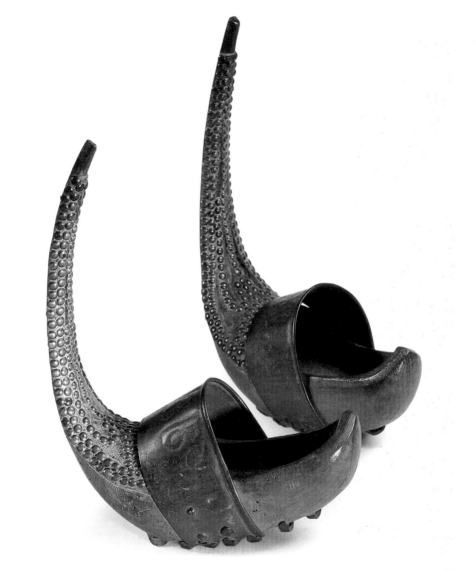

Other types included estivaux, a summer ankle boot of supple, lightweight leather that appeared in the second half of the 11th century; chausses with soles, a type of cloth boot reinforced with leather soles worn with pattens (supplemental wooden under soles) for outdoor use; and heuses, supple boots in a variety of forms originally reserved for gentlemen, but which became common under the reign of Philippe Auguste (1165-1223).

Flat court shoes of Napoleon I
for his coronation in 1804

Lost during World War II

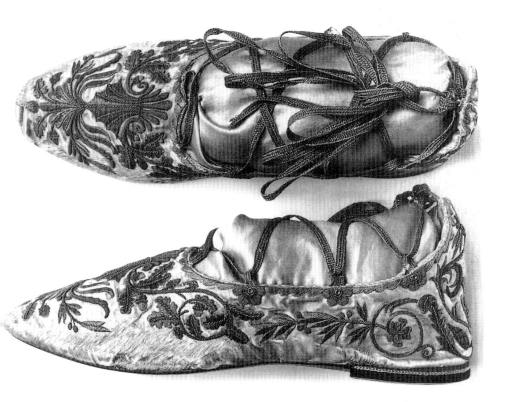

In the early 12th century shoes became longer. A Knight named Robert Le Cornu is credited with introducing shoes called pigaches which were forerunners of the poulaine style.

The Crusaders brought the exaggerated style with its inordinately long tip back from the East. It is based on the raised-toe model of Syrian, Akkadian, and Hittite culture, and reflects the vertical aesthetic of gothic Europe.

Pump in embroidered calfskin

Paris, 1855
Guillen Collection, International Shoe Museum, Romans

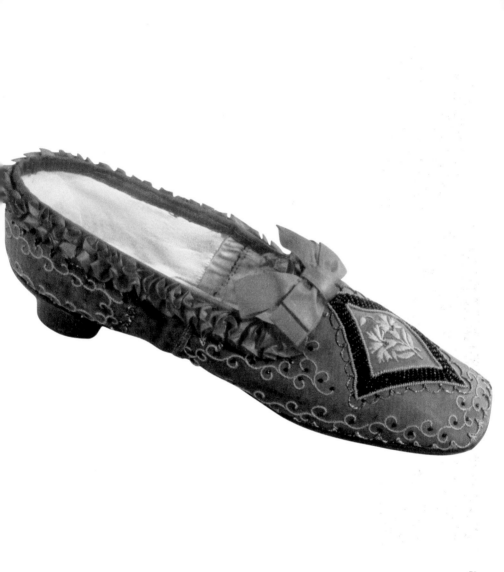

When people of modest means imitated this eccentric fashion initially reserved for the aristocracy, the authorities responded by regulating the length of the shoe's points according to social rank: $1/_2$ foot for commoners, 1 foot for the bourgeois, 1 and $1/_2$ feet for knights, 2 feet for nobles, and 2 and $1/_2$ feet for princes, who had to hold the tips of their shoes up with gold or silver chains attached to their knees in order to walk.

Boots of Imperial Prince Napoleon III

International Shoe Museum, Romans

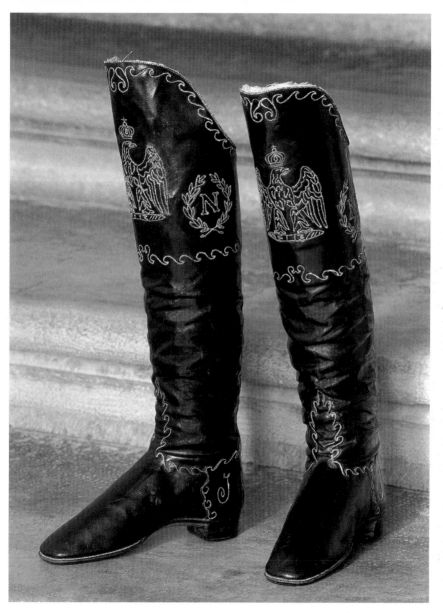

The shoe length hierarchy led to the French expression "vivre sur un grand pied," (to live on a large foot), denoting the worldly status represented by shoe length.

The poulaine was made of leather, velvet, or brocade. The uppers could sport cutouts in the form of gothic church windows, although obscene images were sometimes used.

Slippers of Prince Imperial
Jean Joseph Eugene Louis Napoleon

International Shoe Museum, Romans

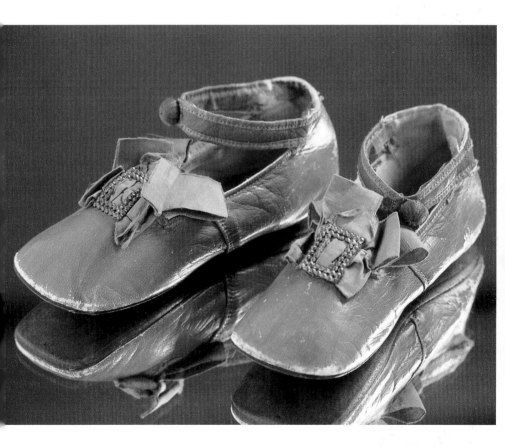

A small round bell or an ornament in the shape of a bird beak often dangled from the tip of the shoe. There was even a military poulaine to go with a soldier's amour. Interestingly, during the battle of Sempach between the Swiss confederates and the Austrians in 1386, knights had to cut off the points of their poulaines because they interfered with combat.

Hand embroidered woman's bottine in satin

Executed by Pinet, Paris, c. 1875
International Shoe Museum, Romans

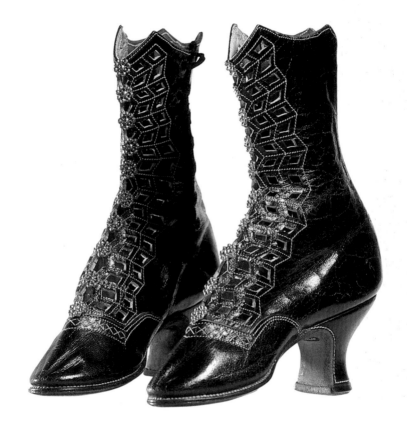

Indeed, the poulaine would only disappear in the early 16th century, after a four-century run.

Flat-soled shoes lasted the entire medieval period, but a heel was beginning to emerge as evidenced in Jan Van Eyck's Arnolfini Couple. The protective wooden pattens, depicted carelessly strewn on the floor in the left of the painting, exhibit an incline: the rear heel is higher than the front support.

Oxford style man's shoe
by A. Biset in light brown kidskin

France, c. 1890
International Shoe Museum, Romans

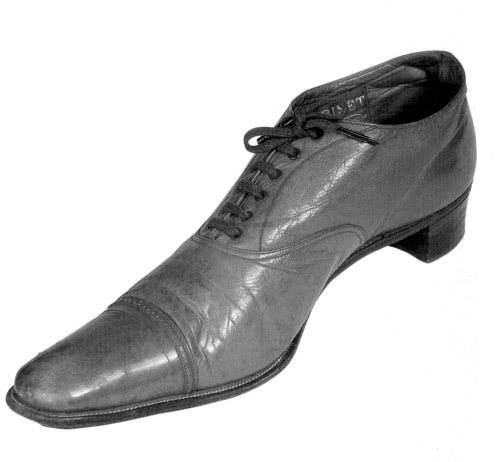

Shoes were scarce and costly items in the middle ages, so protective wooden soles were used for going out in muddy backstreets.

At the end of the 15th century, poulaines fell victim to their own success and ended up popularized for common use. They were succeeded, without the slightest transition, by extremely wide, square-toe shoes designed for the fashion-conscious.

Man's bottine with buttons

France, between 1895 and 1910
International Shoe Museum, Romans

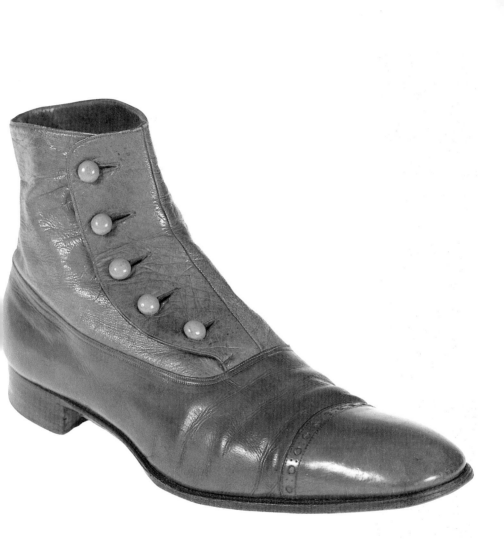

As incongruous with fashion history as it may seem, this shoe was actually inspired by a congenital malformation: King Charles VIII had six toes on each foot, hence the very large toes of his custom-made shoes. The reaction against the previous fashion quickly went too far in the opposite direction.

Bride's shoe

From wedding of 10th November, 1896
Bead design in heart shape
International Shoe Museum, Romans

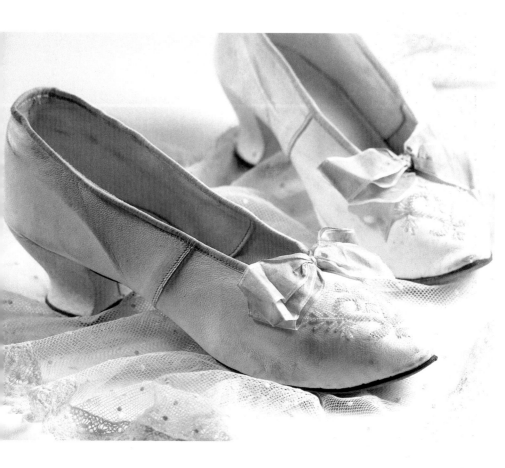

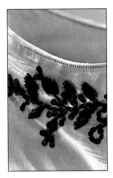

The Valois shoe worn during the reign of Louis XII (1462-1515) occasionally reached widths of thirty-three centimeters. The tip of the shoe, which was stuffed and decorated with animal horns, resembled a cow's head, leading to nicknames such as "mufle de vache" (cow muzzle), "pied d'ours" (bear foot), and "bec de cane" (duck bill).

Woman's shoe

Oxford in white satin, embroidered patterns in silver, tasseled laces. Leather sole, covered reel heel
Executed by Pinet, Paris, c. 1897
Guillen Collection, International Shoe Museum, Romans

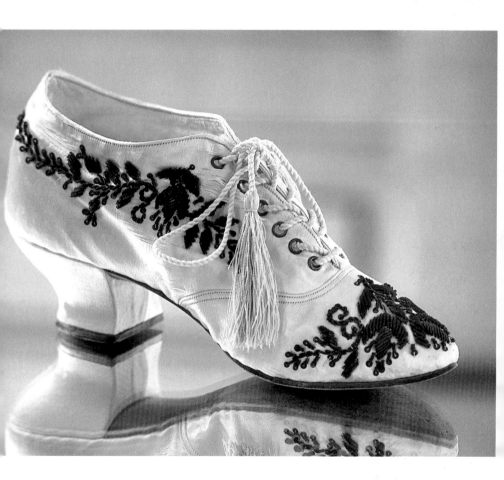

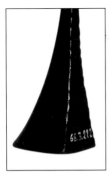

The shoe's eccentric form meant people had to straddle wide in order to walk, which naturally provoked sarcastic remarks.

During this same period, Venetians were wearing shoes called "chopines", also known as "mules échasses" (mules on stilts) or "pied de vache" (cow feet). Attached to the foot with ribbons, these bizarre shoes displayed exaggerated platforms that could reach fifty-two centimeters high.

Mule

Unsuitable for walking, in black kidskin
and sky blue satin, small cabochon in porcelain
Height of the heel: 20 cm
c. 1900, Vienna, Austria
Guillen Collection, International Shoe Museum, Romans

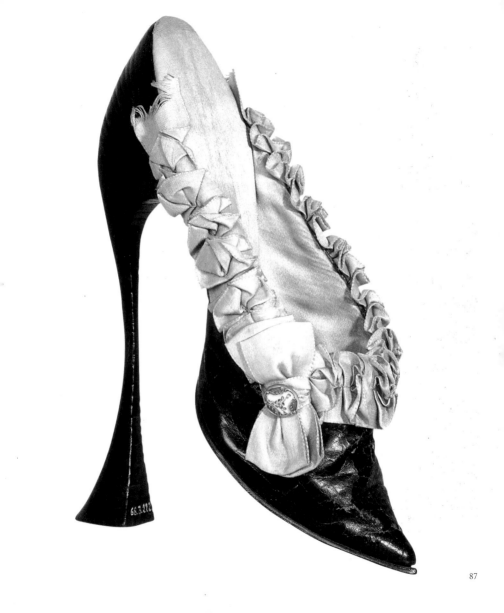

The platforms themselves were of wood or cork and covered in velvet or richly decorated leather. The pantoufle, or mule, was a more moderate style imported from Italy that was first adopted in France in the early 16th century. Made of a thick cork sole without rear quarter, its lightness made it especially suitable for women to wear indoors.

Bottines of the Belle Otéro

Brown and beige kidskin, silver kidskin inlays
Paris, c. 1900
International Shoe Museum, Romans

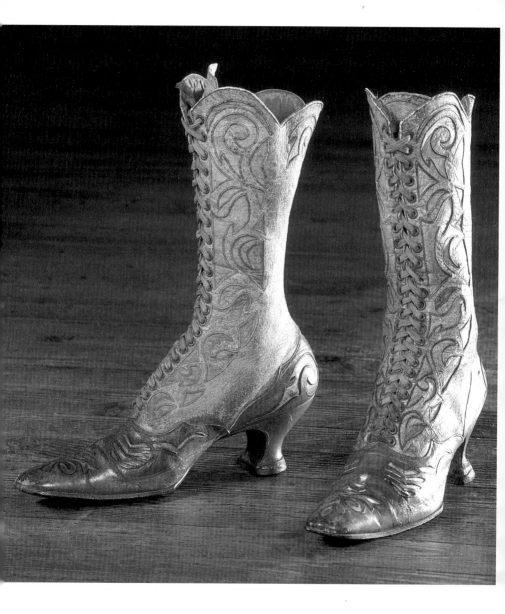

From the reign of Francis I (1494-1547) to Henry III (1551-1589), men and women wore shoes called escarfignons. Also known as eschappins, these were flat slippers of satin or velvet with low-cut uppers and slashes. The horizontal and vertical slashes revealed the precious fabric of the stockings underneath.

Child's shoes resembling a cat's head,
embroidered silk

China, 19th-century
Guillen Collection, International Shoe Museum, Romans

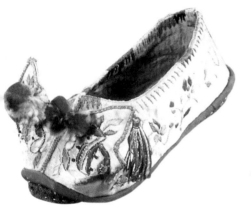
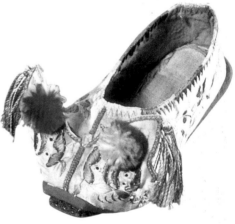

Like other articles of clothing during this period, shoes took after Germanic styles and were decorated with slashes called "crevés".

Leonardo da Vinci is said to have invented the heel, but it did not appear until the end of the 16th century, when it began to rise, most likely in response to the flattering effect of greater height produced by the chopine. The first heels were attached to the sole by a piece of leather.

Court shoe in Dresden China

19th-century
International Shoe Museum, Romans

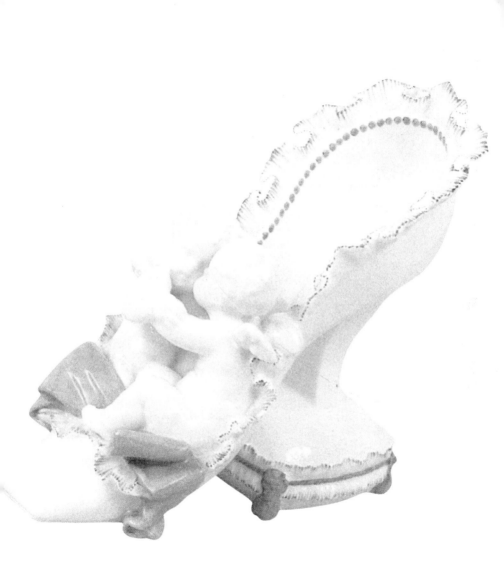

The 17th century witnessed the export of French style throughout Europe. The fragile court shoes of the Renaissance began to disappear during the reign of Henry IV (1553-1610), replaced by sturdy shoes whose uppers slightly exceeded the sole. The toe of 17th century shoes, at first rounded, became square.

Sandal of carved wood

India, 19th-century
Collection of the Musée National du Moyen Age, Thermes de Cluny, Paris, allocated to the International Shoe Museum, Romans

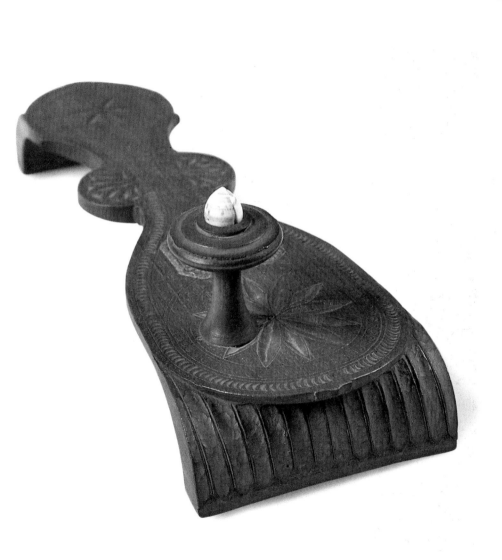

All shoes of the period revealed side openings. The method of fastening the shoe on top was hidden by a buckle or large bow. But the greatest novelty of the period was the heel, which imparted men and women with a form of bearing that would become the customary posture of European courts in the 17th century.

Woman's mocassin decorated
with stylized flowers

Canada 19th century
Musée National du Moyen Age,
Thermes de Cluny, Paris

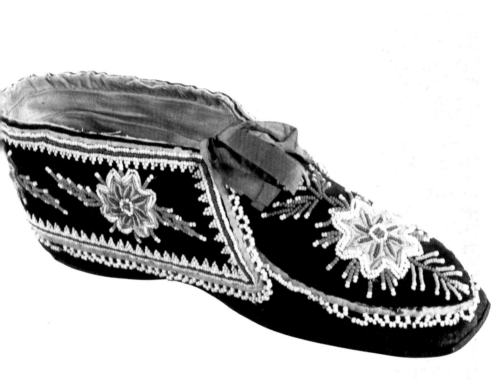

Beginning in 1620, boots called "bottes à entonnoir" or "bottes à chaudron" (caldron boots) could be pulled up over the knee for horseback riding, or allowed to fall around the calf for other occasions. The purely utilitarian heel was positioned under the boot to better support the foot in stirrups.

Marriage shoes of wood inlayed
with windows of mother of pearl, and metal

Middle East, 19th century
Cruller Collection, International Shoe Museum, Romans

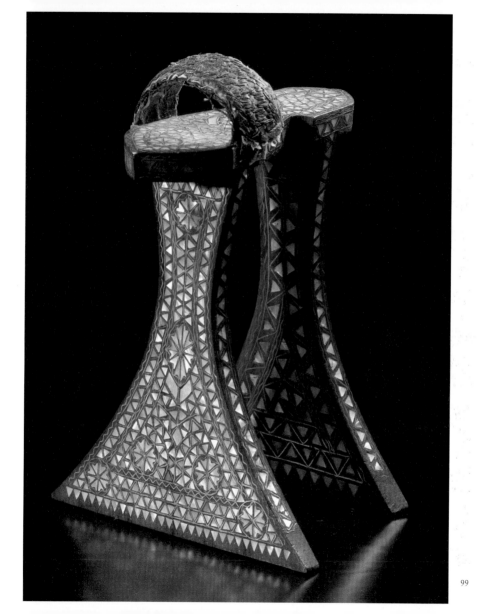

Special fabric boot stockings decorated with lace were worn to preserve the silk ones. Boot stockings were worn with entonnoir boots, which had the disadvantage of becoming a receptacle for water when worn in inclement weather. Lazzarines and ladrines were shorter, lighter boots with an ample cuff that were very popular during the reign of Louis XIII.

Woman's boot in pink satin
───────────────
Gold and black thread embroidery depicting a dragon
China, 19th century
Guillen Collection, International Shoe Museum, Romans

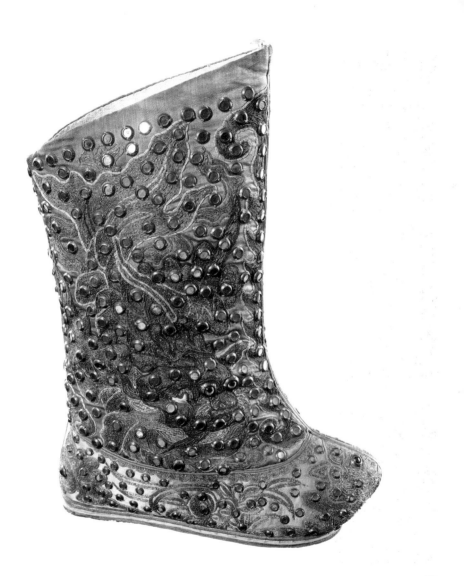

But boots began to disappear from the salons and from court during the reign of Louis XIV (1638-1715), although they were still worn for hunting and in war. Even the heavy boot worn by soldiers until the beginning of the 19th century was gradually replaced in elegant surroundings by a softer version.

Sealskin child's boot

Greenland, 19th century
International Shoe Museum, Romans

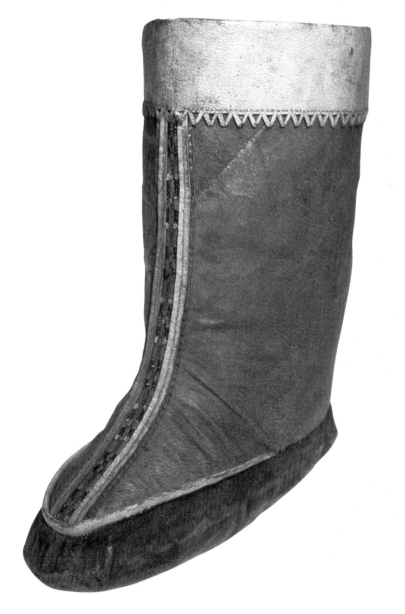

Around 1652, the fashion was pointed shoes; later they became square. Women's shoes were based on masculine forms, but always utilized more refined materials, primarily silk brocade, velvet, and brocart, a rich silk brocade sewn with silver and gold thread. Overshoes called galoches were worn to protect these smart-looking and delicate shoes from muddy streets.

Bottines of Sissi

Empress of Austria, 19th century
Ledermuseum, Offenbach

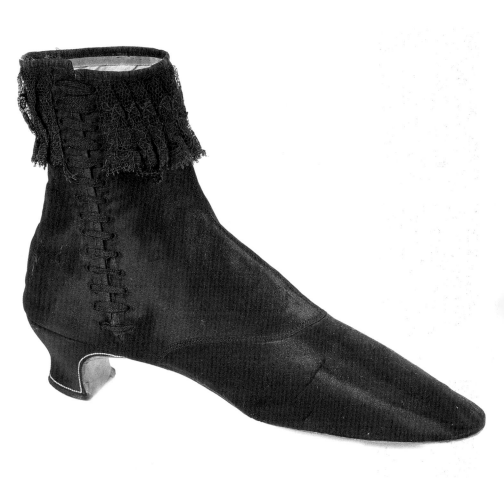

At the beginning of the 18th century, there was little variation in shoe shapes. The toe could be round or pointed and was sometimes raised, but never square. Two different styles were favored: the mule for indoors and high-heeled shoes for more formal outfits.

Boots of Emperor William I of Prussia

19th century
Ledermuseum, Offenbach

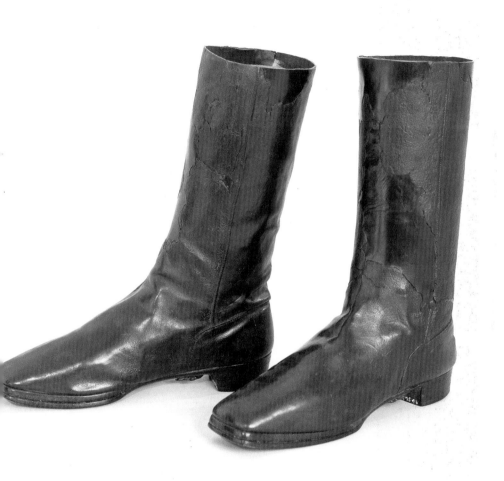

Mules with heels of variable height had uppers of white leather, velvet, or silk, which was usually embroidered. The pinnacle of 18th century refinement would come to be nestled in diamond-encrusted heels, which in this instance were referred to as "venez-y voir" (take a look), although the coquetry was secret, due to the fact that dresses almost touched the floor.

Woman's shoe in bronze kidskin

Double attachment, Charles IX, buttoned on the side, embroidery with gilded metal beads, leather sole, reel heel
19th century
Guillen Collection, International Shoe Museum, Romans

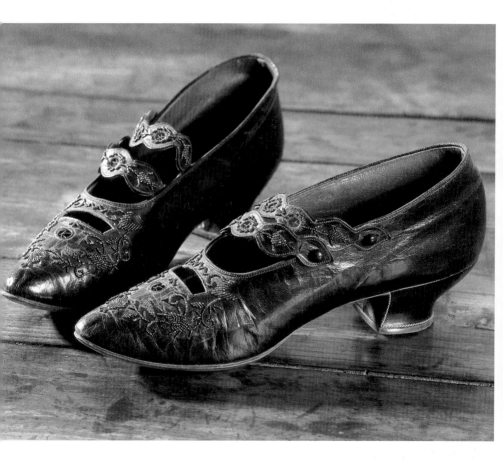

As in the previous century, polished silver buckles, decorated with glass gems or precious stones, were stored in jewelry boxes and passed down by inheritance.

18th century France experienced a passion for the East, as evidenced in historical, economic, and cultural contexts.

Marriage clogs

19th century
Rural Museum of Popular Arts, Laduz

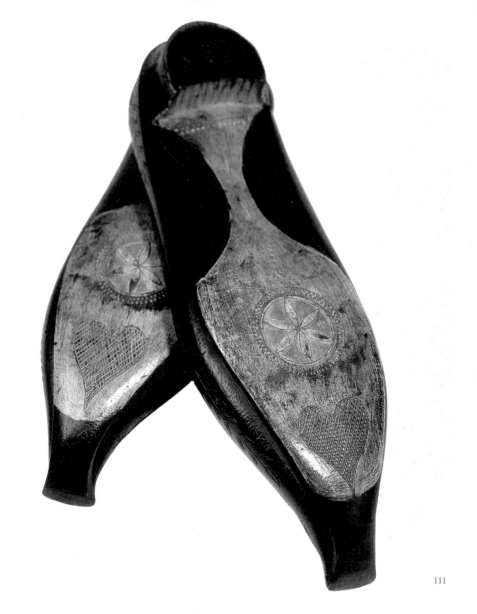

In the context of footwear, the taste for the exotic led to a craze for pointed shoes with raised toes, variously referred to as shoes "à la turque" (Turkish), "en sabot chinois" (Chinese), or "à l'orientale" (Eastern).

Men wore simple, flat-heeled shoes embellished with a buckle. Made of dark-coloured or black leather, these shoes emphasized the light-coloured stockings men wore with silk pants.

Man's bottine

c. 1912
International Shoe Museum, Romans

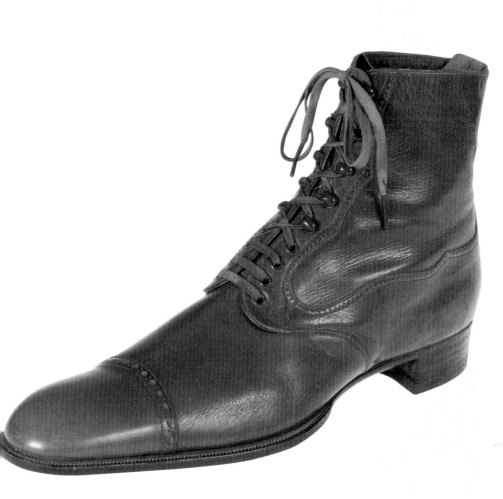

The return to greater simplicity and to straight lines preferred during Louis XVI's reign had its counterpart in footwear. For example, the buckle on men's shoes assumed greater prominence and women's heels became shorter.

19th century women wore woolen ankle boots, but were especially known for their ballerinas of fine glazed leather, satin, or silk.

Duke of Guise by P. Yantorny

Crimson silk velvet embroidered with gold and silver thread
Inspired by liturgical cloths of the 17th century
Louis XV heel, Paris, c. 1912
International Shoe Museum, Romans

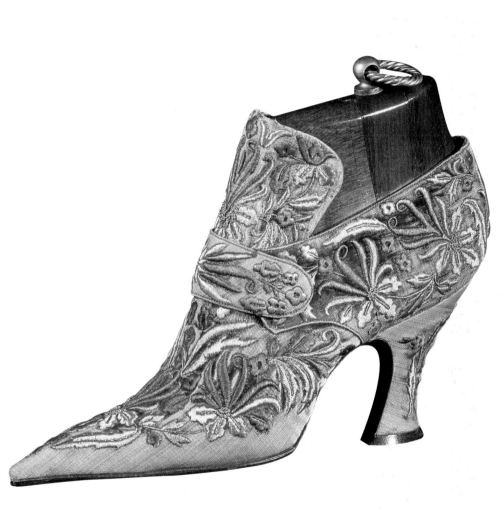

Ballerinas fit a woman's foot closely like a glove and were held by ribbons crossed around the ankle. Very fragile, these ephemeral shoes scarcely lasted the duration of one ball.

As for men's footwear, knee pants and silk stockings reintroduced by Napoleon showed off Empire-style escarpins, flat pumps made of patent leather and decorated with a buckle.

Duke of Guise by P. Yantorny

Background in black satin and applications of red satin bands, buckle adorned with strass and Louis XV heel
Paris, c. 1912
International Shoe Museum, Romans

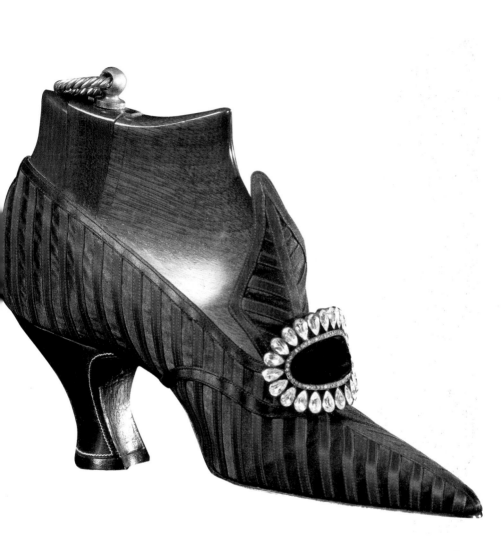

The military-style boot was standard footwear for soldiers; it could be short or tall, with or without cuffs.

During the Restoration and the reign of Louis-Philippe, men wore boots and escarpins made of black leather. Only soft half boots were allowed to be beige, tawny, or brown.

Aviator Boots

c. 1914
International Shoe Museum, Romans

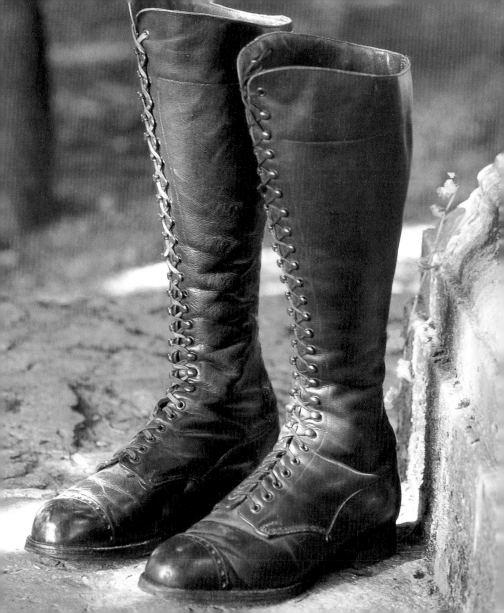

The British dandy George Brummell (1778-1840), better known as "Beau Brummell", wore laced ankle boots with narrow pants. Nicknamed the "fashion king," his clothes become a standard of elegance that knew no boundaries. Women also wore flat ankle boots made of cloth and laced on the side. A taste for satin and silk escarpins tied with ribbons lasted.

Boots of Ninon Vallin worn
in *Marouf le Savetier du Caïre*

Brown suede, applications of turquoise kidskin,
eastern style roll at the end of the vamp
Around 1917. International Shoe Museum, Romans

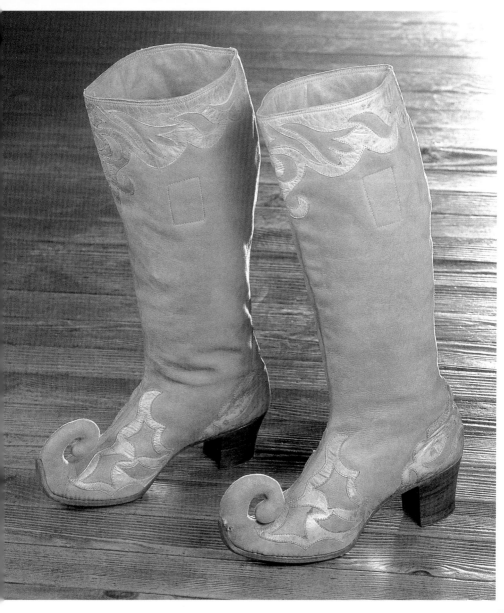

The Second Empire preferred luxury and had an appetite for parties. In contrast to the bourgeois court of Louis-Philippe, that of Napoleon III (1808-1873) proved to be extremely brilliant. The bourgeoisie meanwhile accelerated their rise and pursued financial gain. The ankle boot reigned supreme, made of leather or cloth and very narrowly shaped.

Shoes of Zoya

Pumps in beige kidskin, heel and buckle in amber Russia, around 1920-1925. The heels are exceptional and highly representative of the country's resources. Zoya played the piano in the concert circle

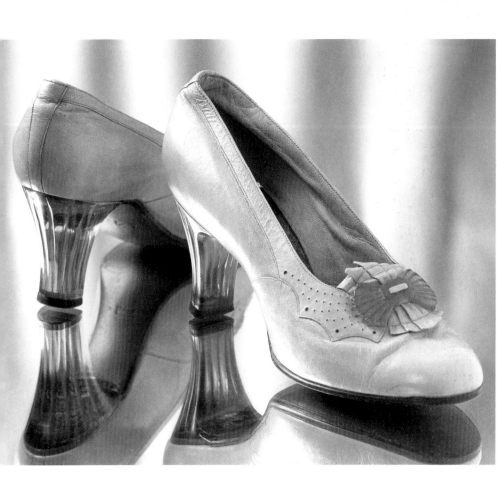

Decorated with embroidery and braids, it was either laced up or buttoned via a row of little buttons, whence the invention of the tire-bouton or buttonhook. The Second Empire also marks a decisive stage in the history of footwear, characterized by advances in mechanization and large-scale industry.

Man's shoe, black suede and black veneer
Man's shoe in white perforated calfskin and black calfskin

UNIC Romans, c. 1923 and c. 1938 respectively
International Shoe Museum, Romans

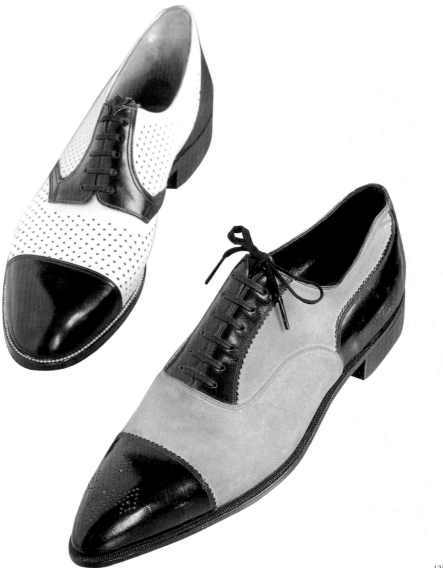

Traditional shoemaking, which changed in 1809 when a machine for tacking soles appeared in England, was transformed by the industrial revolution. In 1819, another new machine made wooden pegs for tacking soles. But the biggest change came from Thimonnier's invention of the sewing machine, patented in 1830.

Woman's pump in silver kidskin

Design of pink dots and small green rectangles in geometrical spaces largely leaving visible the silver background. Covered Louis XV heel. Leather sole.
Discovered by shoemaker, Gillet, Paris c. 1925.
International Shoe Museum, Romans

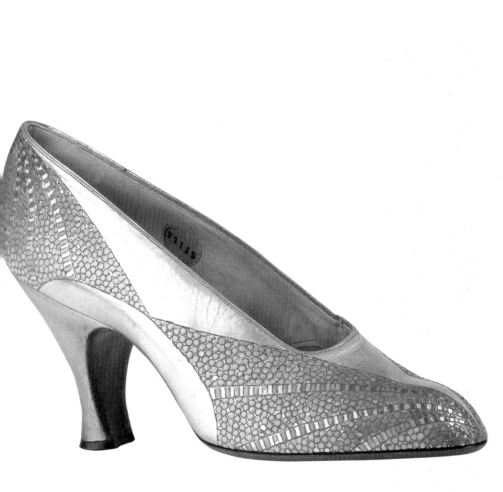

A perfect invention, the sewing machine made it possible to stitch uppers of soft materials and began to spread among shoemakers in 1860. The technique improved their production yields, as machines positioned the heel, stitched the upper, and attached the upper to the sole.

Evening shoes in navy blue velvet, steel bead design, celluloid heel inlayed with strass

Created by shoemaker Hellstern, c. 1925
International Shoe Museum, Romans

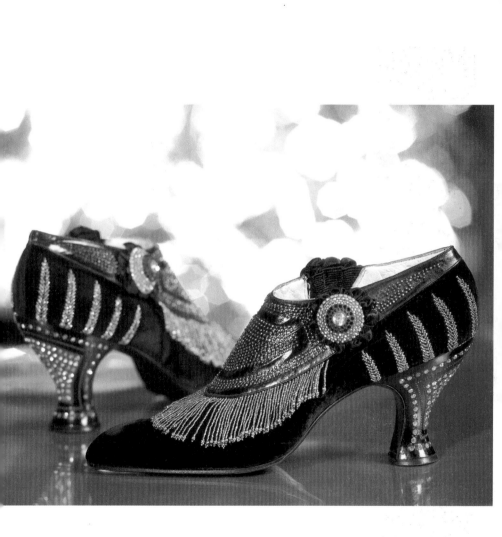

After 1870, it became common to use a form for each foot, which enabled shoes to correspond to anatomy. Industrial development began to overtake hand-made shoes as factories were established and expanded.

The shoe's history and evolution in the 20th century can only be understood in relation to the personalities and the older firms that paved the way to our understanding of traditional and industrial fabrication.

Pump by Julienne

c. 1925
Large bakelite buckle decorated with white beads, application in red kidskin
International Shoe Museum, Romans

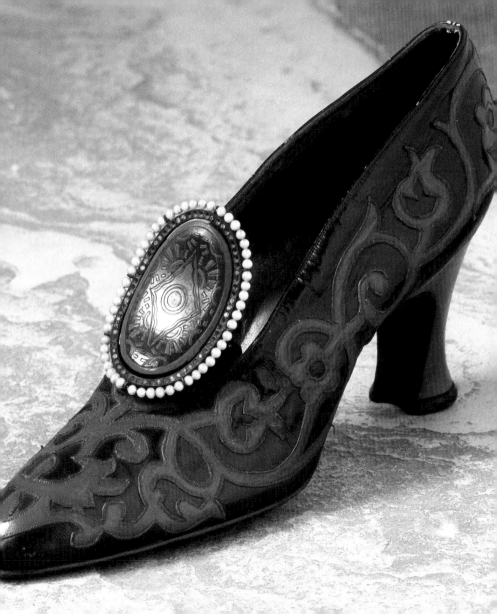

True "dynasties," some of these custom shoemakers and manufacturers are still growing into the 21st century. Many names are cited here taken from among the talented designers and prestigious firms, but also many are absent, as this book cannot pretend to be exhaustive.

Woman's pump from shoemaker A. Gillet in the Charles IX style in garish green silk

Paris, c. 1928-1930
Applications of gold kidskin
and Louis XV costume heel
Discovered by shoemaker, Gillet, Paris
International Shoe Museum, Romans

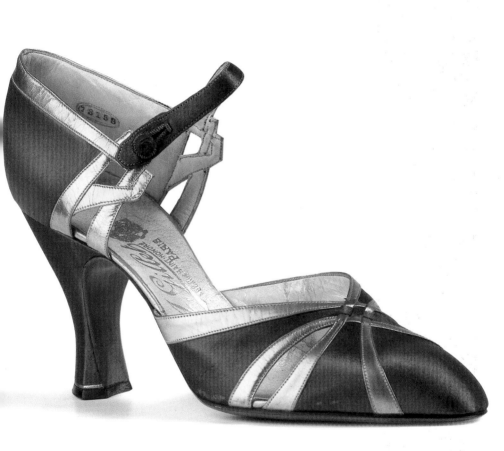

133

All deserve greater recognition, not only for their contribution to the rise of fashion in France and the world, but also for passing their traditional know-how on to the next generation.

It is also impossible to understand 20th century footwear in isolation from its closely related historical, economic, and artistic contexts.

Evening sandal in gold kidskin,
cork platform sole covered with gold

Perugia. Style created for Arletty, 1938
Charles Jourdan Collection
International Shoe Museum, Romans

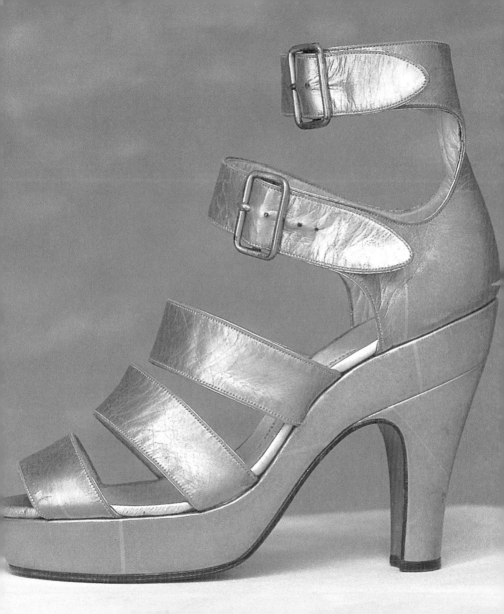

These underlying factors would lead to a revolution in clothing that would produce the versatile functionality of modern apparel. To fashion designers who deemed shoes a fashion accessory these factors were rich sources of inspiration. Many historical factors contributed to the evolution of 20th century shoes.

War shoe
───────
1942
vamp made up of strips of cloth and skins
fitting of boiled hide, square heel
wooden sole of blades attached to canvas
Charles Jourdan Collection
International Shoe Museum, Romans

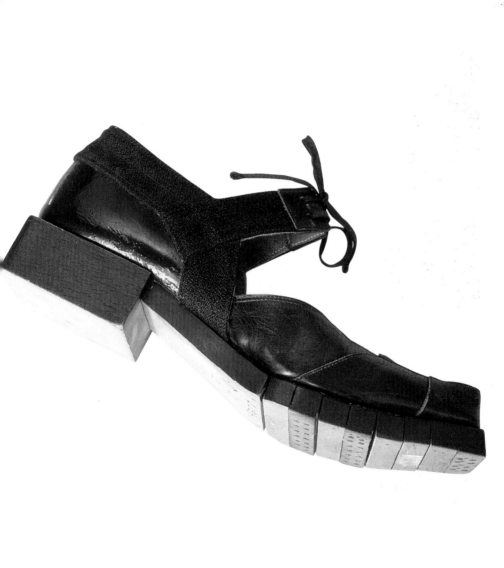

First, the rise of international relations promoted foreign influences, while large world fairs, in which French couture participated, facilitated artistic exchange. Second, Haute Couture fashion shows and the informative role of fashion magazines, spread by photography and film, were among the principal agents of change. To these factors must be added the growth of sports and the introduction of the automobile.

Sandal in nylon and gilded leather

Salvatore Ferragamo, 1947
Ferragamo Museum, Florence

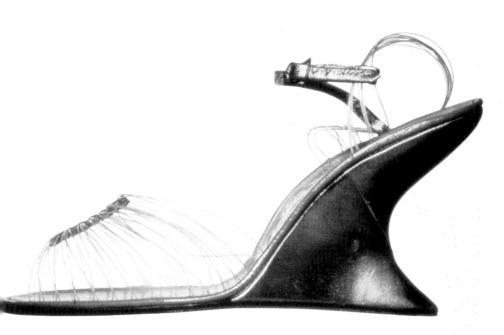

Additionally, a wealthy French and foreign clientele that only wore custom-made clothing and shoes continued to exist alongside the booming apparel industry, a phenomenon that enabled mass production of Couture-inspired fashions accessible to the largest number of consumers at lower prices, which in turn promoted the growth of the shoe business.

Charles IX in maroon satin, platform sole, straight heel, gold kidskin design imitating paintwork

c. 1947
Creation by Sarkis Der Balian

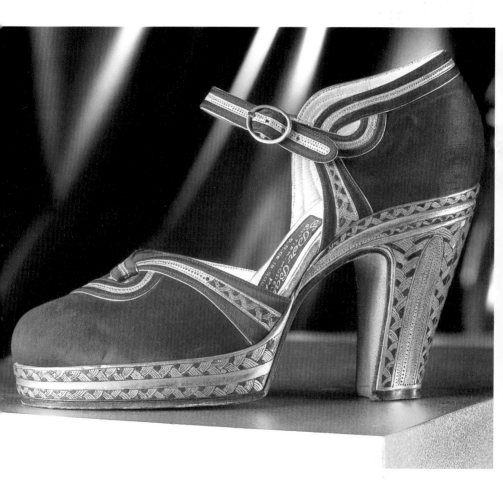

In this way names like "André" and even "Bata" became the pride of footwear's mass-market. The impact of the two world wars would also be considerable. Finally, the advent of Designer Fashion and technological innovations in footwear would carry shoes into the 21st century.

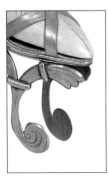

Thigh boots in pink kidskin mounted on a winged shoe with volutes in gilded bronze, fastening at the front by seventeen buttons

Hellstern
Paris, c. 1950

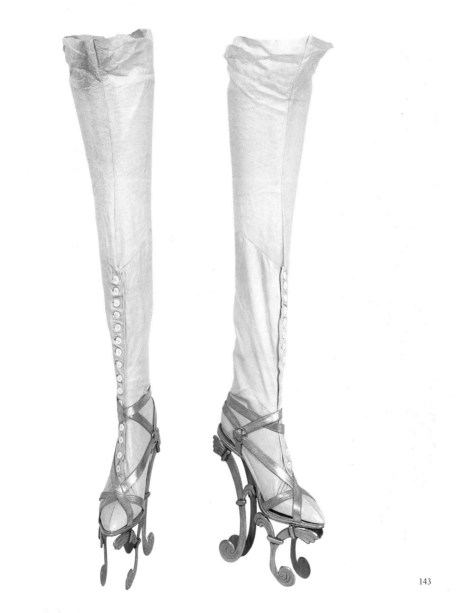

A number of events marked the years around 1900: the advent of the lady's suit revolutionized fashion; the English craze for sports and fresh air established itself in France; and a bathing suit that included cloth ankle boots with rubber soles was transported to Etretat and Trouville.

Heel-less shoe in purple velvet calfskin, lace of gold kidskin, base of polished cork colored gold

Perugia, 1950
International Shoe Museum, Romans

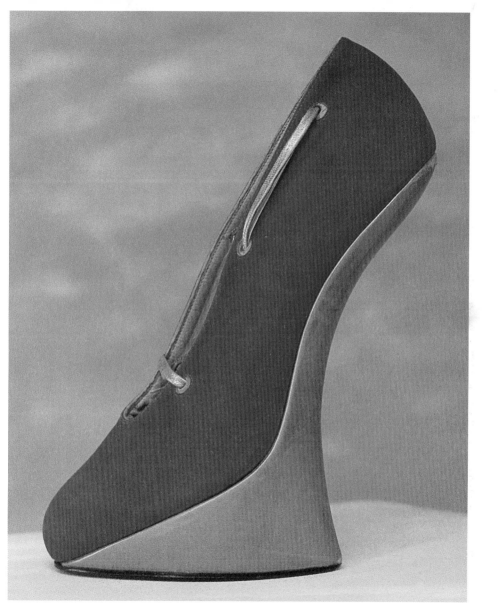

Women who risked bicycle riding dared to wear baggy pants inspired by bloomers and caused a sensation by showing their feet in shoes. From 1900 to 1914, couturiers proliferated, riding the wave of la Belle époque and the house of Worth. There were Paquin, the Callot Sisters, Doucet, and Lanvin, among others.

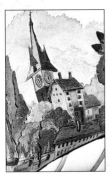

Zurich

Ankle-boots made from parchment in laid with natural leather
Zurich as seen from the window of the town hall
Creation by Sarkis-Der-Balian
Paris, 1950

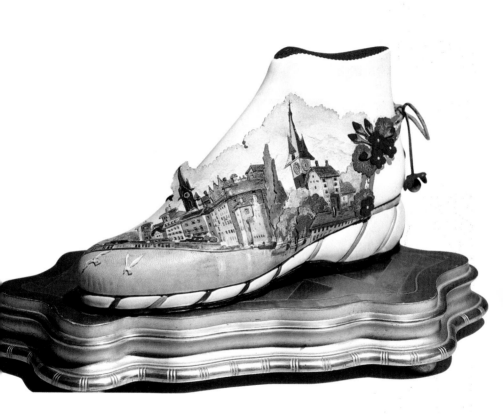

Ladies of society and courtesans sank fortunes into their outfits. The "nouveaux riches" strutted about, arrayed in their most beautiful finery, trying to project an image of their newly acquired affluence. Until 1910, the button or lace-up ankle boot of "gold," beige, or black was standard for winter, whereas the covered shoe was worn in summer.

Cinderella

Fairy-tale discovered on a velvet shoe covered with tiny multi-colored sequins
Creation by Sarkis-Der-Balian
Cinderella, Paris, 1950

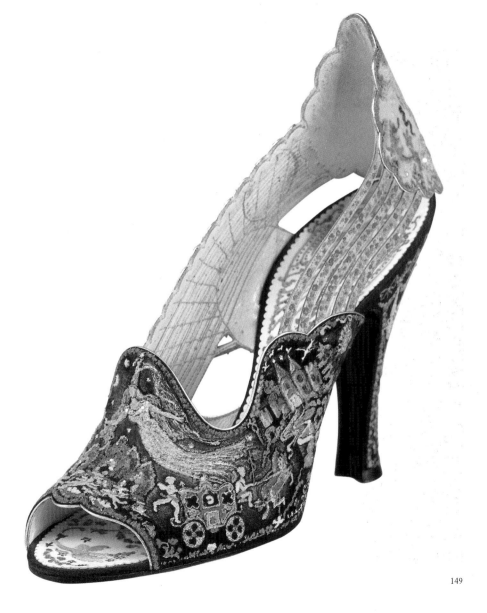

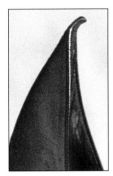

Deep-cut shoes with Louis XV heels and a pointed toe box were the height of sophistication for evening, worn with matching dress and stockings. Elegance for men amounted to wearing button ankle boots, but low, top-laced shoes accompanied outfits for sports and casual wear.

Evening sandal in red satin
and gold kidskin, style created for Jacques Fath

Perugia, c. 1953
Charles Jourdan Collection
International Shoe Museum, Romans

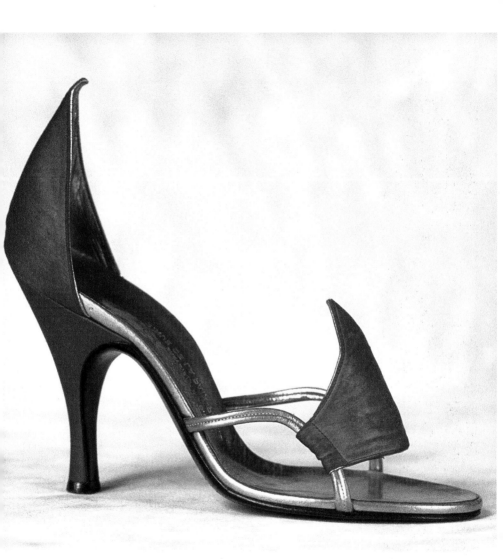

151

Most of these shoes were made by artisans scattered around Paris working anonymously, making shoes rapidly, but skillfully, on demand, before the flowering of renown custom shoemakers became commonplace.

World War I (1914-1918) disrupted the whole society's living conditions. Women, for example, found themselves having to cover for men in the most diverse jobs.

Seducta pump

1954
International Shoe Museum, Romans

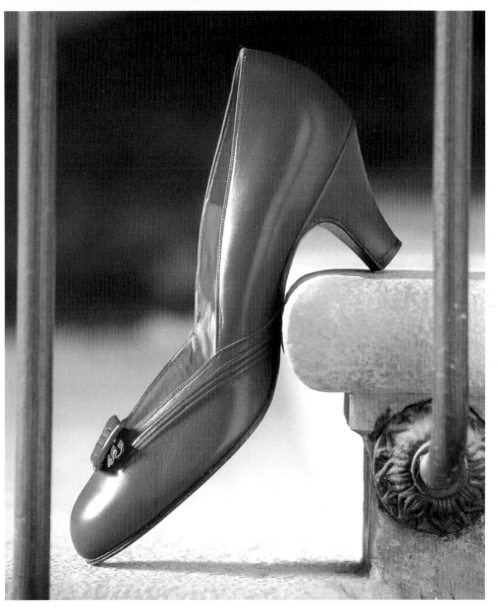

In this way they experienced a need to dress more practically in a fashion that allowed their feet unrestricted movement. Now highlighted, the shoe quite naturally acquired a new elegance. The Roaring Twenties succeeded the terrible war years. Women cut their hair and the short skirt claimed a definitive victory.

Sandal

———•———

c. 1955
Red and blue kidskin, forepart in the shape of toes
metal arch, geometric heel
Perugia style after a painting by Picasso
International Shoe Museum, Romans

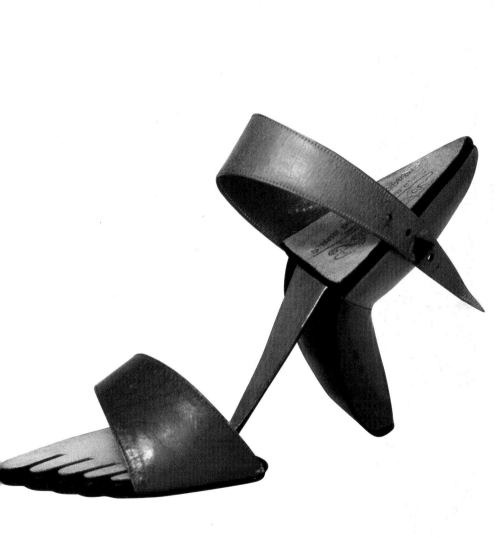

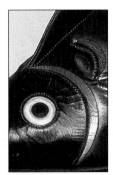

Long boots and black stockings gave way to light-coloured stockings to set off new shoes available in all the colours of the rainbow. Men's top-laced shoes, often covered with a small gaiter of black or gray wool, gave the illusion of an ankle boot. In the 1930s, Elsa Schiaparelli and Coco Chanel set the tone for fashion, and with the added influence from Madeleine Vionnet, evening gowns descended in length, emphasizing the figure's lines with a bias cut.

Pump

Perugia, c. 1955
Kidskin, black glaze, upper shaped as a fish
heel composed of a metal blade enameled black,
style modeled after a painting by Braque
Charles Jourdan Collection
International Shoe Museum, Romans

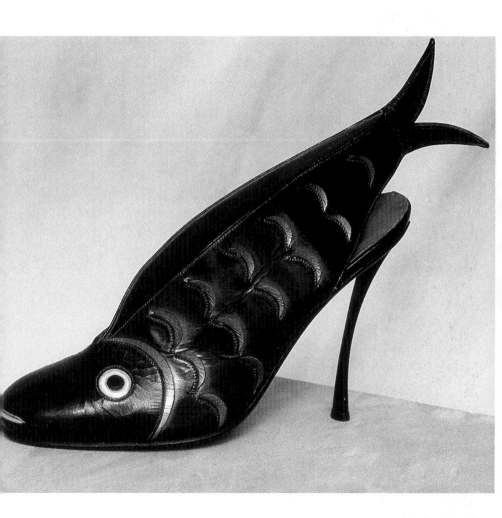

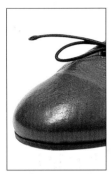

In response, shoes became more slender, heels became higher, and shoe buttonholes tended to be hidden. Flats and crepe-sole shoes were worn with outfits for sport. At the same time, at the dawn of the Second World War, wedge soles appeared. Wartime leather restrictions imposed on the entire population turned wedge soles into a standard style.

Elastic pump created
for Madame Grès (beachwear)

Massaro, 1955

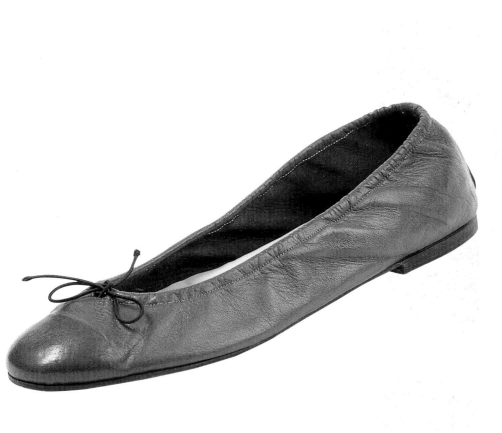

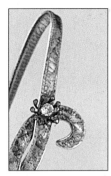

Unfortunately, wood (brightly painted or covered in fabric) and cork wedges were uncomfortable and ugly, although the innovation of the articulated wooden heel would provide some extra ease in walking. Designers also used substitute materials such as raffia and felt to make the uppers.

Flora

———

Creation by Sarkis-Der-Balian
Paris, for the world cup, won in 1955

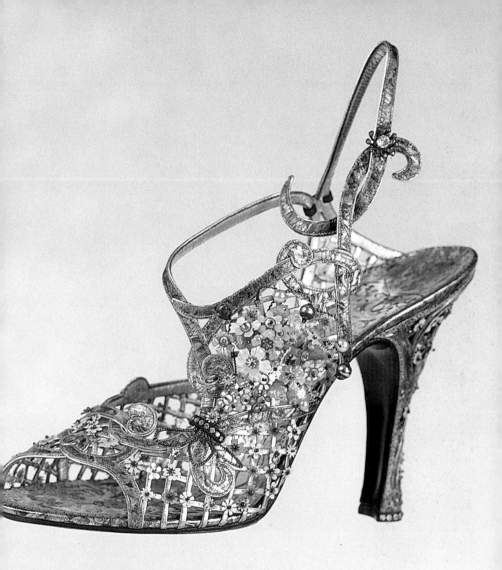

These heavy wedged shoes became pedestals for a straight silhouette with broad shoulders, until after the Liberation in 1947, when Christian Dior launched his "New Look." A very Parisian style, the New Look was characterized by a cinched waist and a large skirt that fell below the calf, worn with slender heels in perfect harmony with the silhouette.

Style created for Sophia Loren,
beads and motifs embroidered in satin

Salvatore Ferragamo, 1956
Ferragamo Museum, Florence

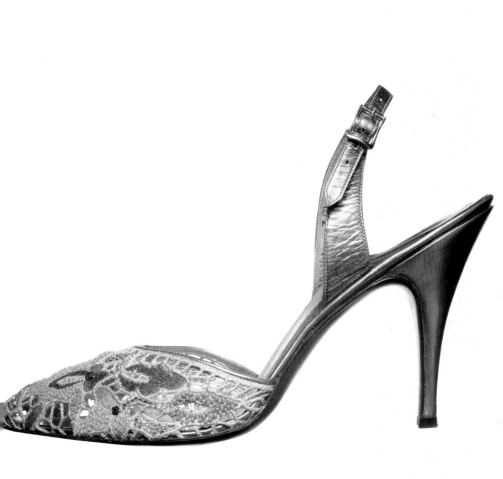

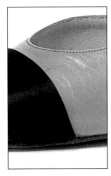

Henceforth, in the mind of designers, an elegant women's outfit would be unthinkable without high-heeled shoes. The stiletto heel was thus born in reaction to the heavy shoes associated with the war. A metal core guaranteed the heel's stability, but the stiletto left perforations in the floors of public places until a protective tip was invented.

Shoe created by Raymond Massaro for Chanel

1958

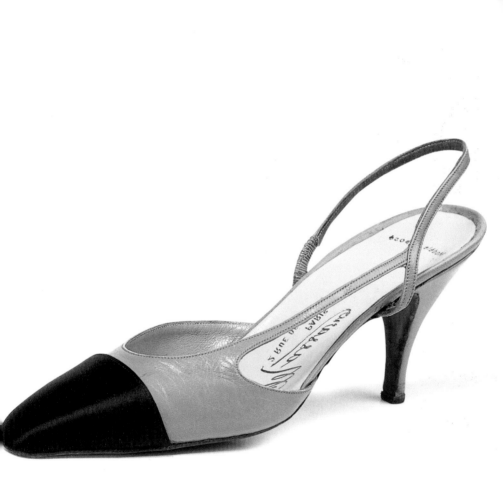

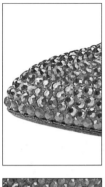

The heel survived until the 1960s, although its profile became slightly curved underneath the sole. The popularity of the mini-skirt led to its disappearance and shoes with round toes (succeeding pointed toes) replaced the stiletto. Two styles dominated store shelves: the Richelieu (the front upper sewn over the back upper) and the Derby (the back upper sewn over the front upper), while the moccasin, a shoe without laces, attracted a young clientele.

"Low-cut" pumps of Marilyn Monroe decorated entirely with red Swarovski strass, strass covered heel

Created by S. Ferragamo for the film *Let's Make Love*, directed by George Cukor in 1960
Ferragamo Museum, Florence

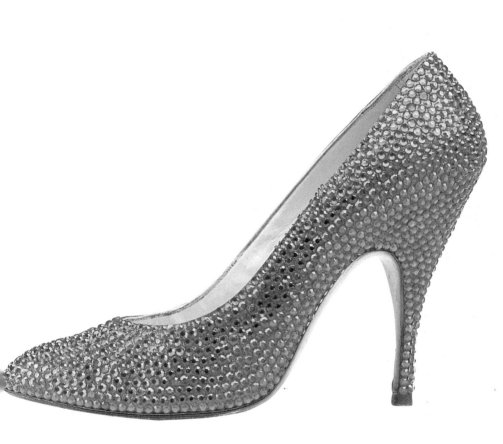

According to Sylvie Lefranc, head of the Bureau de Style de la Fédération de l'Industrie de la Chaussure de France (Fashion Office of the French Shoe Industry Federation) consumers lacked access to a wide range of shoe styles and products in the early 1960s. A malaise of sameness pervaded all the product lines, except for those of prestigious custom shoemakers, which were only available to the privileged few.

Shoes of Paul Bocuse worn for the competition for the Best Worker in France in 1961

Moccasin style in black kidskin
International Shoe Museum, Romans

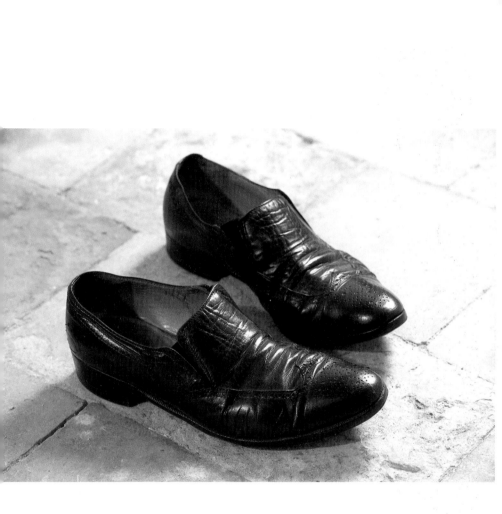

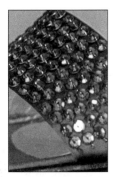

Enter Roger Vivier, who had the innovative genius to pave the way for modern consumerism. In a manufacturing partnership with Société Charles Jourdan, Vivier launched a ready-to-wear line of fine shoes that were expensive but still affordable to a large number of consumers. Vivier was able to express his personal talent for bold silhouettes and the use of sophisticated materials in the line.

Evening sandal

Blue satin, sequin embroidery, "Comma" heel
Created by Roger Vivier. Paris, 1963
International Shoe Museum, Romans

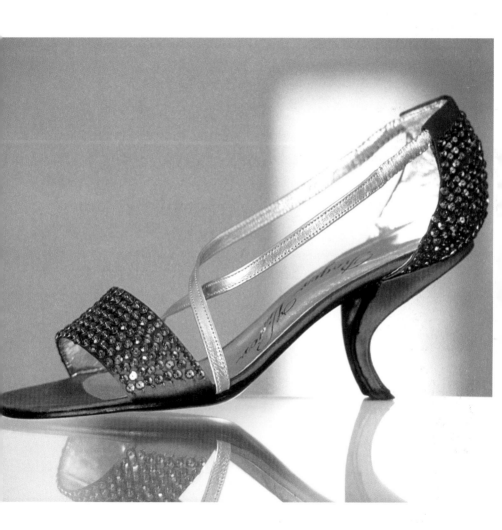

The democratization of elegance gathered momentum as a trend and marked the advent of Designer Fashion footwear: new products were henceforth the subjects of aesthetic research, and contours and volumes were stylized to reflect the personality of their designer.

"Pull-Over"

Style created for Brigitte Bardot in 1966
Bottine covered in velvet
Ferragamo Museum, Florence

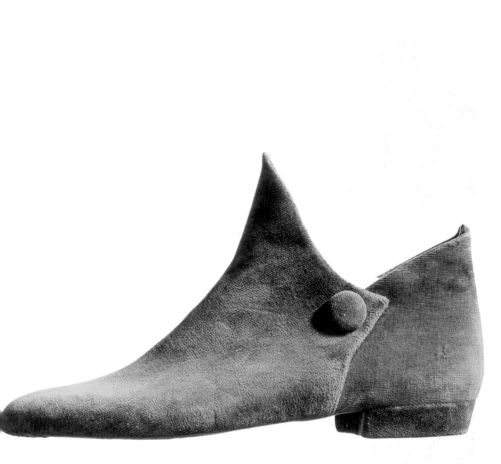

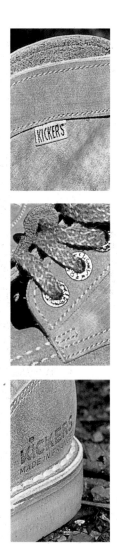

Among the designers who had the ability to impart their own unique and identifiable look to their shoes were Roland Jourdan, following in the footsteps of Roger Vivier with his stylistic exercises focused on heels; Robert Clergerie, who lent his prestige to masculine and feminine style by creating new shapes; Stéphane Kélian, the inventor of the feminine braid and riding boot wizard; and finally, Walter Steiger, who handled line with a true designer's meticulousness.

Children's boots, Kickers

1971
International Shoe Museum, Romans, France

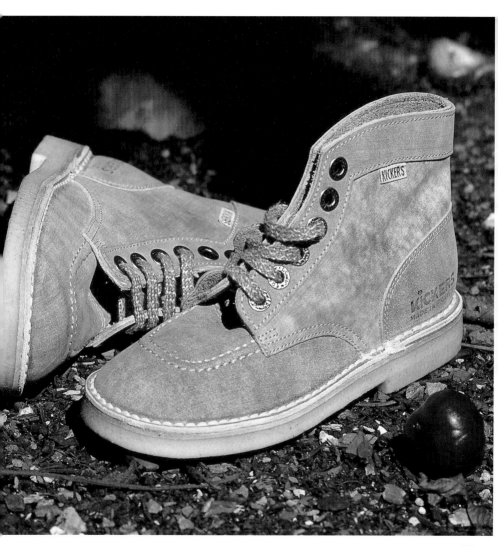

This new generation of fashion designers strongly influenced the 1970s and triggered a real craze among female consumers, who were passionate about shoes elevated to the full status of fashion objects.

Alongside the phenomenon of sophisticated urban fashion that had developed in reaction to the banality of standard shoes, there appeared a new trend generated by lifestyle.

Suede boot with tendril heel

Creation of François Villon
Paris, 1980-1981
International Shoe Museum, Romans

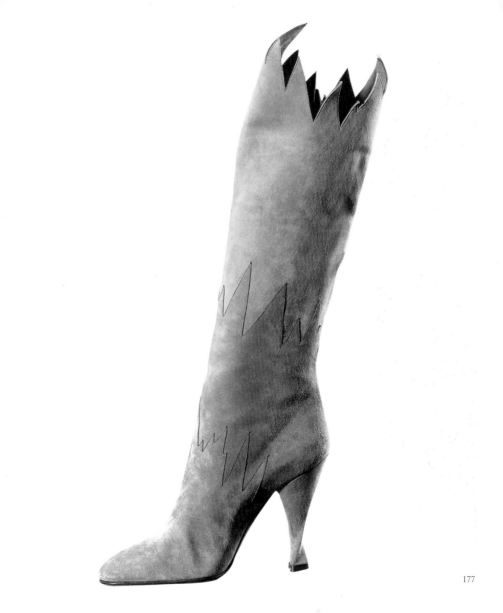

Originating in the United States and winning over Europe, the trend amounted to the advent of sportswear and jeans, or the casual look. Kicker's founder Daniel Raufast recognized the significance of the trend (it was especially marked in the youth and children's markets starting in the early 1970s) and developed a casual, playful product in response.

Shoes of Jacques-Henri Lartigue

Photographer, 1980
International Shoe Museum, Romans

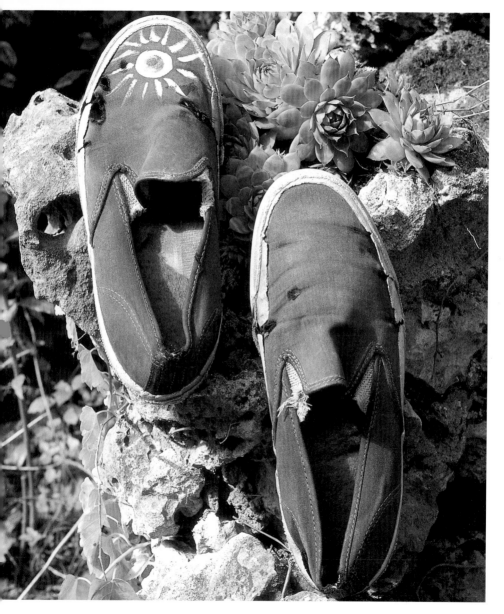

During the same period, Mr. Helaine of Arche introduced a small, super-soft, and colourful boot that was distributed around the globe. The world of adventurers and nostalgia for pioneers and soldiers attracted a new generation of young men, as footwear with a history – Clark's Desert Boots, Pataugas, and Palladium's Pallabrousse – was adopted for leisure and weekend wear.

Pumps worn by Romy Schneider in the role of Marthe Hanau in Francis Girod's *The Banker*

1980

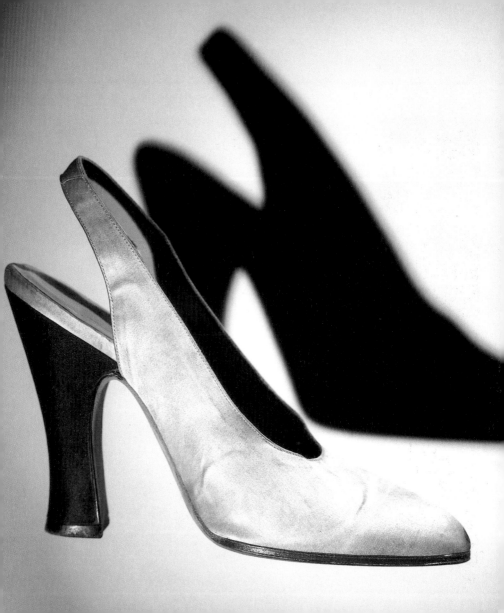

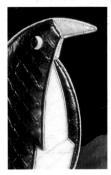

New milestones in technical performance were reached in the 1970s with the successful introduction of rubber soles molded on fabric uppers; once the movement was launched, there was no turning back.

Beginning in the 1980s, sportswear ceased to be the only source of inspiration for new styles, as the active sports themselves dictated the rules.

"The North Pole" farandole of penguins in snake skin on suede ankle boot

Andrea Pfister, winter 1984-1985
International Shoe Museum, Romans

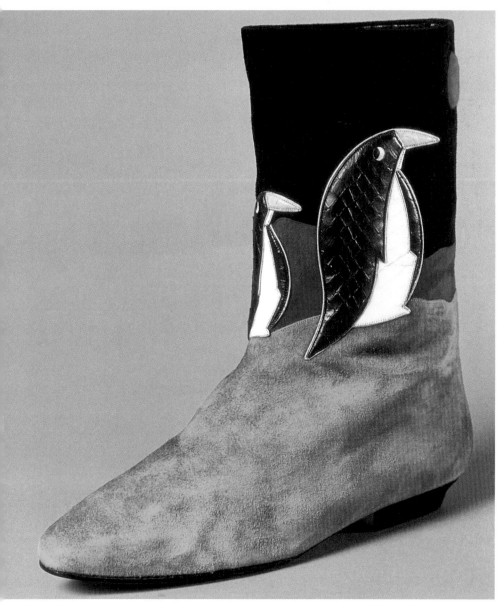

The Girbauds were among the pioneers in this area, co-opting specific items from various sports contexts and giving them the right to be cited. The major specialized brands followed suit by going after the youth market: Adidas, Reebok, Converse, Puma, and Superga became fashion players in their own right. Events happened quickly in this industry segment, but it should be noted that Nike played an important role in developing new lines featuring modernist design.

Poulaine style shoe

Velvet, pendants and beads, "Clown" heel
Created by Roger Vivier, Paris, 1987
International Shoe Museum, Romans

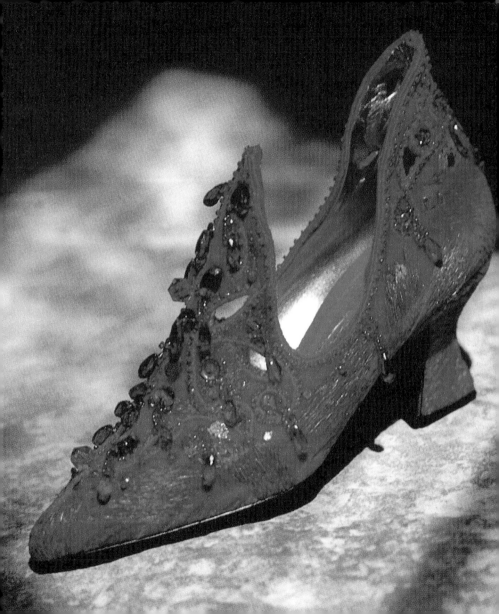

Other fashion trends arose from an openly ecological approach – before anyone had ever heard of the Greens. These currents persisted over the decades, ever faithful to the cult of the natural, ergonomics, and authenticity. Bama, Birkenstock, and even Scholl were among the leaders to whom the contemporary Camper is heir.

"Legs" pumps for Azzedine Alaïa

Raymond Massaro, 1991
Black glaze, red kidskin and red base,
Achieved using resin, the "leg heel" was hand carved

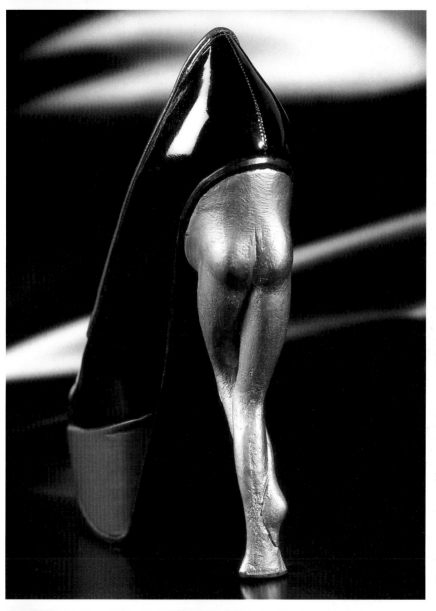

Fashion's 360-degree turn toward more intimate and primary values privileged the person over appearances and is especially evident in footwear, which is an accurate reflection of contemporary lifestyles.

Sportswear now "contaminates" the world of elegance as well. What couture house does not have running shoes and high-tops in their collection? Even men have been seduced by the casual chic of Tods and Hogan, after experiencing the sturdy comfort of Paraboots.

Shoe created by Massaro

1992

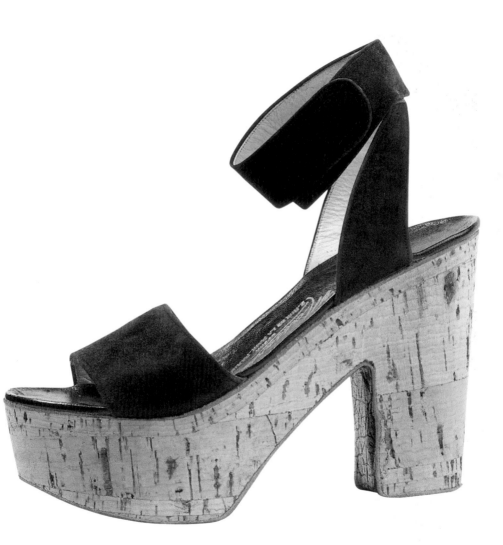

But Cinderella's slipper still inspires fantasy, and elegance and glamour exist now more than ever. Sophisticated women's shoes today have new defenders. New designers carry the torch of the great artists of seduction, redesigning new contours and original heels, playing with materials and decoration: Rodolphe Ménudier, Michel Perry, Manolo Blahnik, Pierre Hardy, and Benoît Méléard are among the most visible.

Hand woven boot, Winter 1994
Hand woven shoe, winter 1998
Hand woven sandal

Stéphane Kélian
International Shoe Museum, Romans

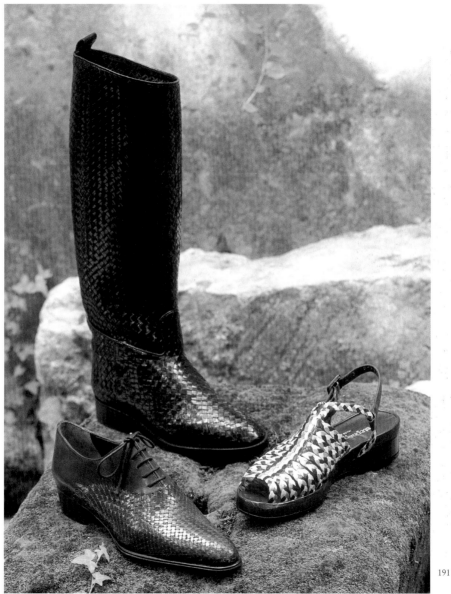

The rapid change in footwear, from both a design and manufacturing perspective, is perfectly illustrated by the careers of the most illustrious custom shoemakers: Andrea Pfister, Berlutti, Ferragamo, Massaro, and Yantorny. Each name represents a different trajectory, but all stand for devotion to excellence.

Mules

Robert Clergerie, Spring-Summer, 1998
International Shoe Museum, Romans

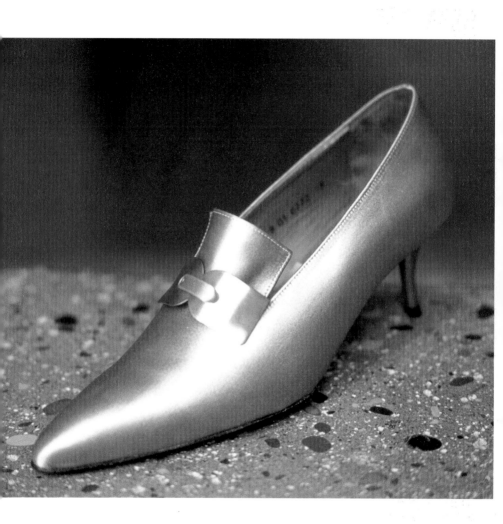

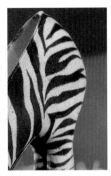

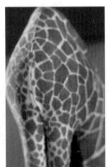

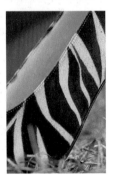

Shoe designers:

André Perugia

André Perugia was born in Nice, France in 1893 of Italian parentage. He trained in his father's workshop and in 1909 opened a shop in Paris where he sold his hand-made shoes. He later moved to Rue Faubourg St Honoré to continue his work. It was his work for the fashion designer Paul Poiret that was to bring him success.

Giraffe pump and zebra pump in kidskin and velvet painted entirely by hand

Heels of carved wood covered with hide evoking the hind legs of a giraffe and a zebra. Created by Stéphane Couvé Bonnaire, winner of the competition under the category for the stiletto heel organized by the Style Bureau of the National Federation of the Shoe Industry in 1995, International Shoe Museum, Romans

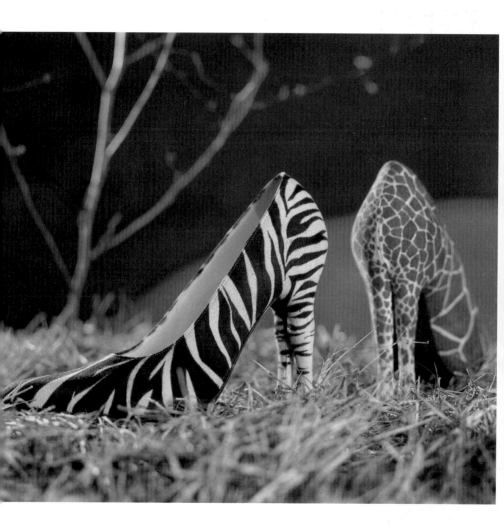

Among his clients were the stars of the Folies Bergere and film actresses who desired shoes that reflected the glamour of the stage. Perugia was always eager to experiment with new materials as well as shapes which enabled him to establish his mark of extraordinary originality.

Sandal
———
Robert Clergerie, Spring-Summer, 1998
International Shoe Museum, Romans

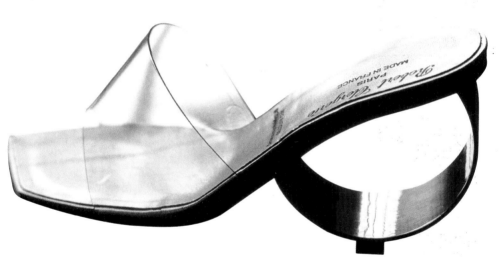

Not only did Perugia work for several fashion designers such as Elsa Schiaparelli and Givenchy but he also made shoes in homage to famous artists, notably George Braque and Pablo Picasso.

Sandal

Robert Clergerie, Spring-Summer, 1998
International Shoe Museum, Romans

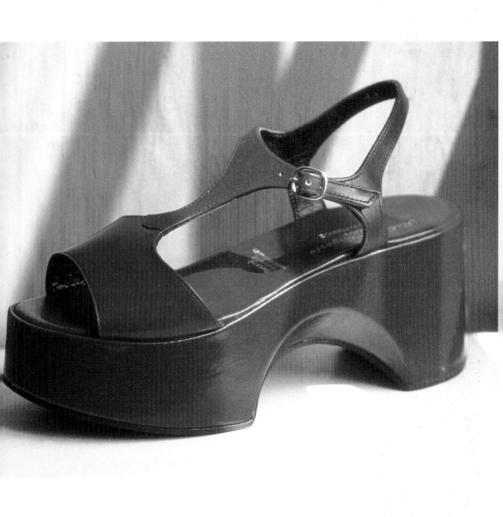

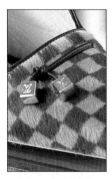

André Perugia said "a pair of shoes must be perfect, like an equation and adjusted to the millimetre like a motor piece." His designs also included shoes with interchangeable heels and even heel-less heels. His work spanned the 40's, 50's and 60's. He retired in 1970 and died in 1977, aged 84.

Louis Vuitton open checked pump

Paris, 1998
International Shoe Museum, Romans

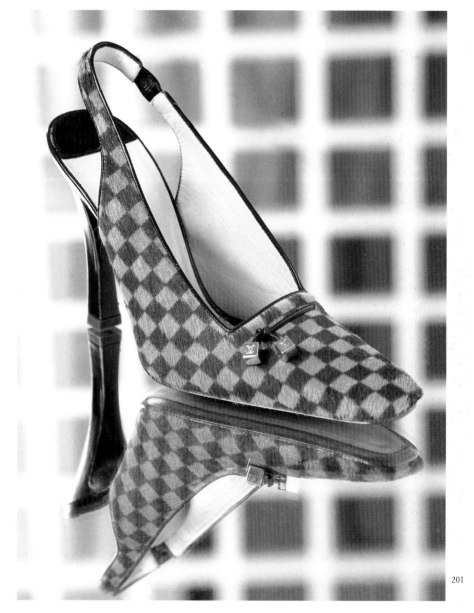

Salvatore Ferragamo

Salvatore Ferragamo was born in Naples, Italy in 1898 and made his first pair of shoes at the age of nine. At the age of 16 he emmigrated to the USA and lived in California where he opened a shoemaking and repair shop in Santa Barbara. Ferragamo studied anatomy at the University of Southern California to discover how weight falls on the foot. His education helped him to perfect the steel arch support that he inserted into the instep of every shoe.

Shoe of Mouna Ayoub

Created by Raymond Massaro for Chanel
Spring Summer 2000
Private collection

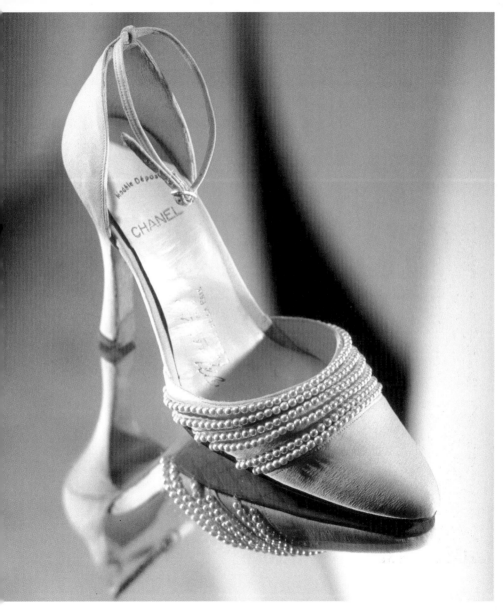

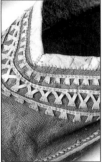

In 1927, Ferragamo returned to his native land where he settled in Florence to set up a shop. All the world's top fashion magazines were in love with his shoes and he made shoes for all the famous Hollywood film stars including Audrey Hepburn. He was noted for his diverse use of materials such as needlepoint, lace, raffia and cork. He died in 1960, but his children continue his business.

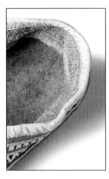

Men's shoes

Seal and walrus skin
Alaska, beginning of the 20th century

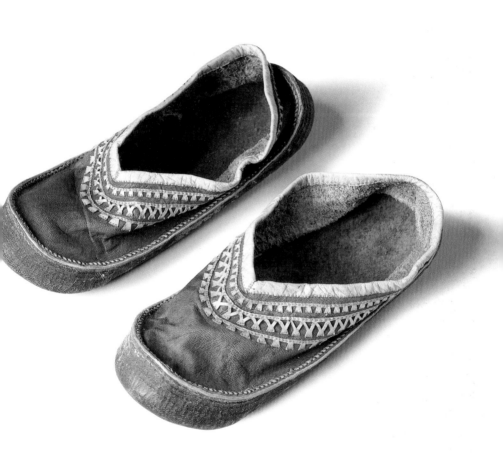

Andrea Pfister

Andrea Pfister was born in Pesaro, Italy in 1942. In 1961, he took a course in shoe design in Milan and in 1963, he established himself as a designer for Lanvin and Jean Patou. After showing his shoes he opened his first shoe shop in 1967. His shoes are famous for being colourful, stylish and daring. Some of his most unique designs were made during the Surrealist years. As Pfister himself says: "it's impossible not to smile when you wear a pair of my shoes."

Marriage shoes of Queen Elizabeth II

Bally Museum, Schönenwerd, Switzerland

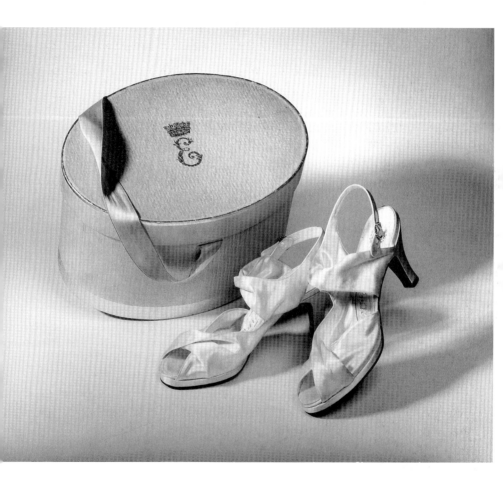

Pietro Yantorny

Pietro Yantorny was born in 1890 in Calabria and is one of the world's most expensive shoe designers. In the early years of the 20th century, he had a shoe shop in Paris which was notorious for its high prices, possibly due to the time he took in making his shoes. His gorgeous custom-made shoes are famous for their use of silks and diamante buckles which today survive as souvenirs of unsurpassed glory. He died in 1936.

"Tomato" mule by Andrea Pfister

Spring-Summer 2002
International Shoe Museum, Romans

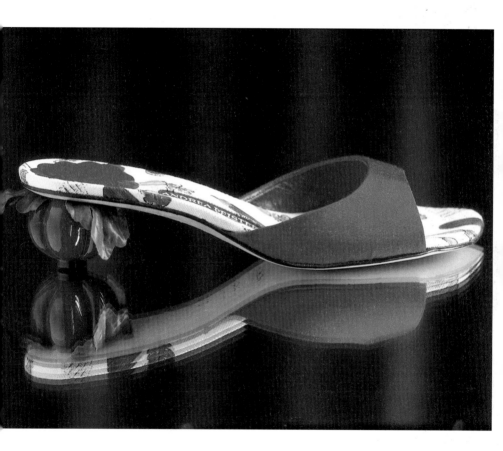

Roger Vivier

Roger Vivier was born in Paris in 1913. He studied sculpture at the Ecole des Beaux-Arts in Paris, until some friends invited him to design a collection of shoes for their workshop. He worked alongside several other shoe designers too. In 1937, he opened his first shop. He designed for major names such as Pinet and Bally in France, Miller and Delman in the United States of America and Rayne and Turner in the United Kingdom.

"Carrot" sandal

Andrea Pfister, Spring-Summer 2002
International Shoe Museum, Romans

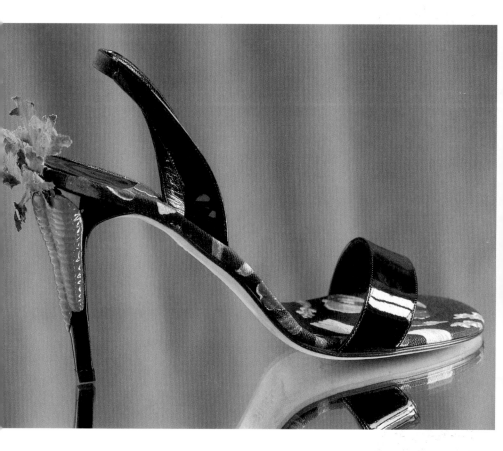

In 1953 Vivier was appointed as a shoe designer for Christian Dior where he designed some of the most important shoes of the period. One of his pairs was worn by Queen Elizabeth on her coronation in 1953. In 1963 he reopened his own shop in Paris and continues to produce two collections of shoes per year, under his own label. If anyone has redefined our notions of the shoe, it is Roger Vivier.

Shoes created by Patrick Cox in honor of the Golden Jubilee of Queen of England Elizabeth II in 2002

Creation limited to fifty copies
Gift of Patrick Cox
International Shoe Museum, Romans

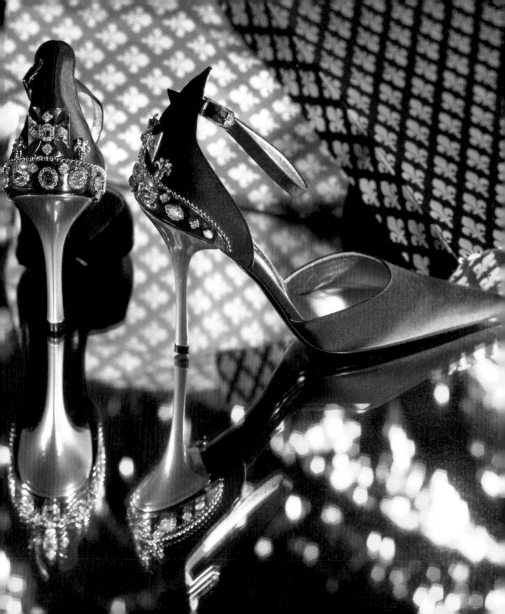

Julienne

Julienne set up her shop in Paris in 1919 at 235 rue St Honoré. She specialized in fine shoes. Her designs reflect the exotic and elements of the colonial style.

Sarkis Der Balian

Der Balian was born in Aitab Cilicia, Armenia in the early 20th century. He arrived in France in 1929 to practise the art of shoemaking in various workshops in Paris.

Child's mule decorated
with a marguerite, synthetic sole

Summer 2002
International Shoe Museum, Romans

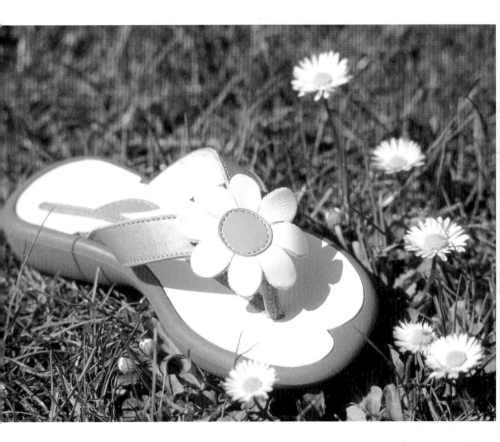

He worked independently and in 1935 he toured Italy where he designed many pumps, sandals and shoes. The comfort of his shoes merited the label 'Der Balian.' He died in 1996.

Raymond Massaro

Massaro was born in 1929 and went to the Ecole des Métiers de la Chaussure. For more than a century Massaro has had the priviledge of a private, refined and exigent clientele.

"Double T" shoes

Created by Tod's, Spring-Summer 2003

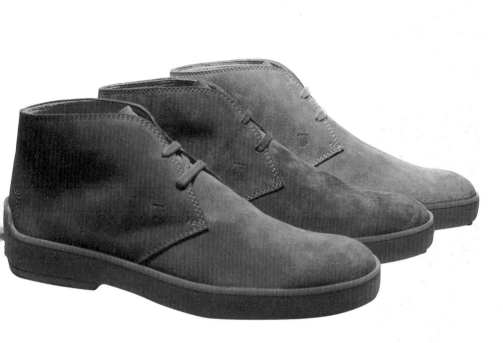

Marlène Dietrich, the Duchess of Windsor and the Countess Bismark are some of the most famous clients known to have chosen Massaro shoes. It was in 1967 that Raymond took over his father's firm and follwed in his footsteps. He puts his creative talent into service designing for Christian Dior, Jean-Paul Gautier, Karl Lagerfield as well as Chanel.

"Opium" mules

Dress of the Akha tribes of the Golden Triangle
(box of recycled coca and jungle seed, 6 cm steel heel, leather)
Trikitrixa, Paris

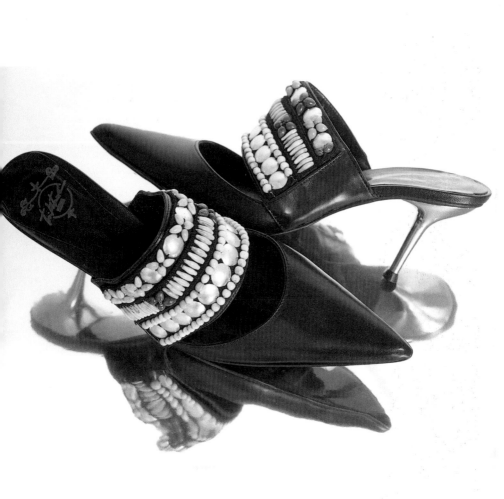

François Villon

François Villon was born in 1911 and created his own label in 1960. His designs were highly successful and they attracted a refined and famous clientele. His style did not always keep up with the vagaries of fashion. He created both practical and elegant shoes and opened several boutiques abroad. He died in 1997.

"Akha" sandal

dress of the Akha tribes of the Golden Triangle
(box of recycled coca and jungle seed, 6 cm steel heel, leather)
Trikitrixa, Paris

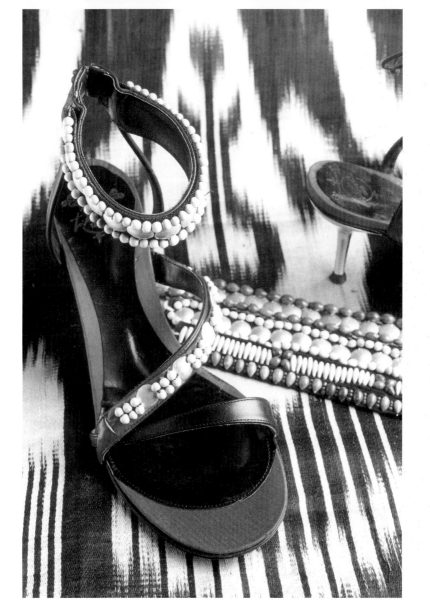

Robert Clergerie

This 64 year-old designer is still creating and crafting beautiful women's shoes in the small town of Romans in Provence. Clergerie has worked for Charles Jourdan and bought Fenestrier, a men's shoe factory. Not long after he launched his name which epitomised quality, comfort and creativity.

"Rosette" sandals with pheasant feathers

Trikitrixia, Paris

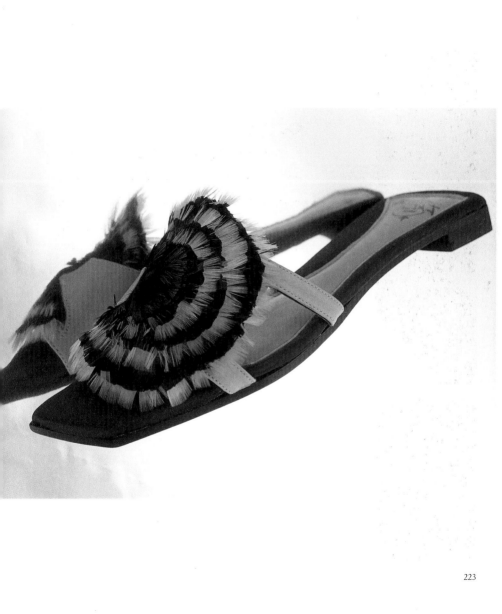

Despite his success, Robert Clergerie wants to remain on a small scale so that he can guard his high quality standards thanks to traditional craft methods. His shoes are sold in all major cities of France and Europe and are now also in Japan and in the United States.

Alessandro Berluti

Berluti was born in 1865 in Senigallia, Italy. He was extremely clever with his hands and initially learnt how to craft things out of wood.

Masterpiece by P. Yantorny: shoe of feathers

International Shoe Museum, Romans

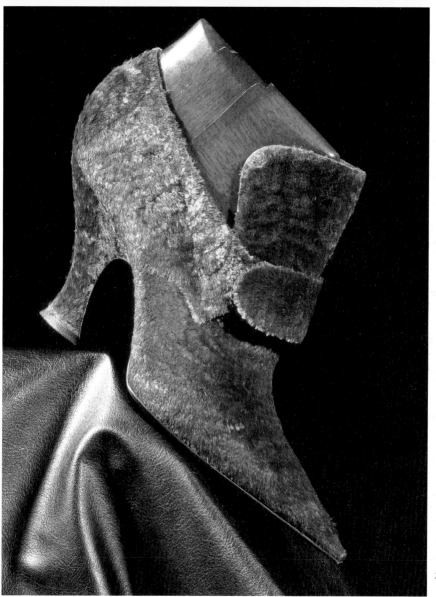

Eventually he decided to work with leather. He arrived in Paris in 1895 and practised the craft of shoemaking for ten years. He created custom-made shoes. In 1900 the World Fair offered him a chance to make himself known to a larger public. Upon his return to his native country he ran a workshop until his death. He would pass on all his secrets of the art to his son Torello.

Fakir's sandal

India
Collection Guillen
International Shoe Museum, Romans

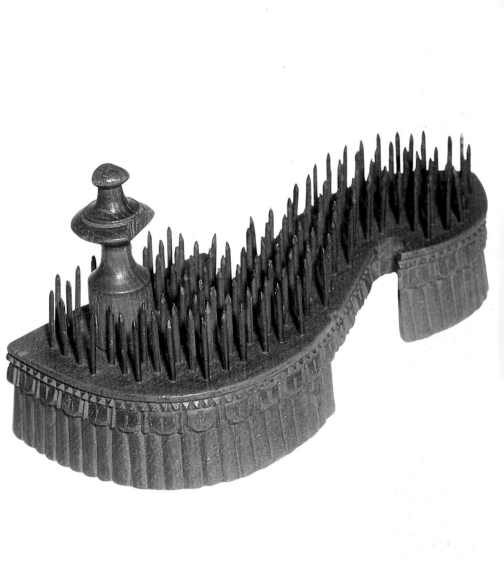

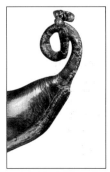

John Lobb

John Lobb trained as a bootmaker in London before moving to Australia. He set himself up in business in Sydney in 1858 and entered a pair of his boots in the Great Exhibition in 1862 for which he won an award. He later sent a pair of his best riding boots to the Prince of Wales and was awarded a Royal Warrant. He then returned to London to found his business.

Hooked toe Shoes

India
Bally Museum, Schönenwerd, Switzerland

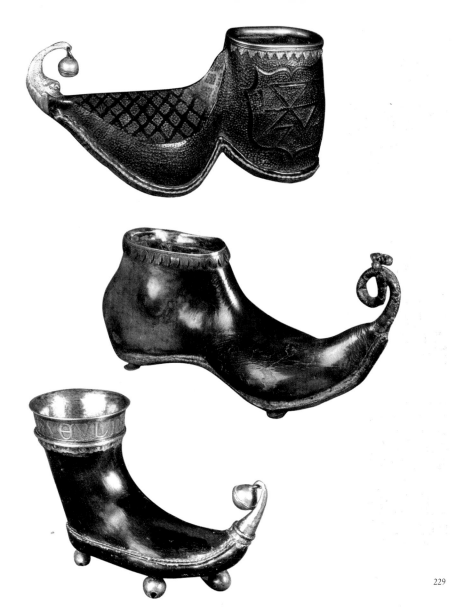

Lobb's designs appeal to a wealthy clientele for whom he makes golf shoes, oxfords and moccasins. Today, the John Lobb family firm holds an unprecedented three Royal Warrants as Royal Bootmaker to Her Majesty Queen Elizabeth II, His Royal Highness the Duke of Edinburgh, and His Royal Highness the Prince of Wales.

Man's boot in ribbed black satin

Thick sole with sewn leather
Guillen Collection
International Shoe Museum, Romans

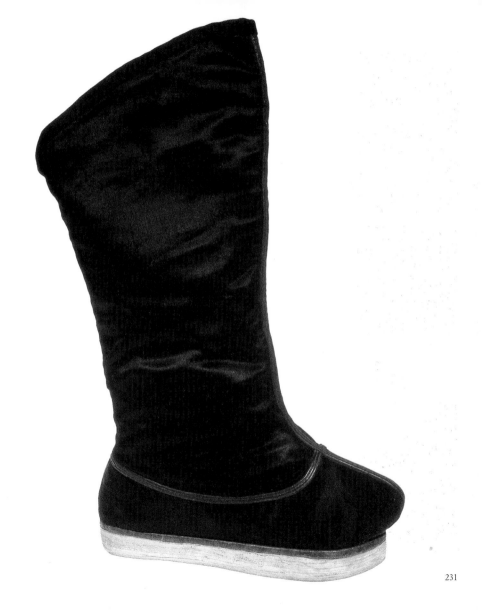

Patrick Cox

Patrick Cox was born in Edmonton, Canada in 1963. His early interest in the British fashion scene brought him to Cordwainer's College, London. Whilst a student he designed shoes for Vivienne Westwood and subsequently went on to design for John Galliano. He actually started his career making shoes in 1985.

Marriage shoes

China
Collection of Beverley Jackson

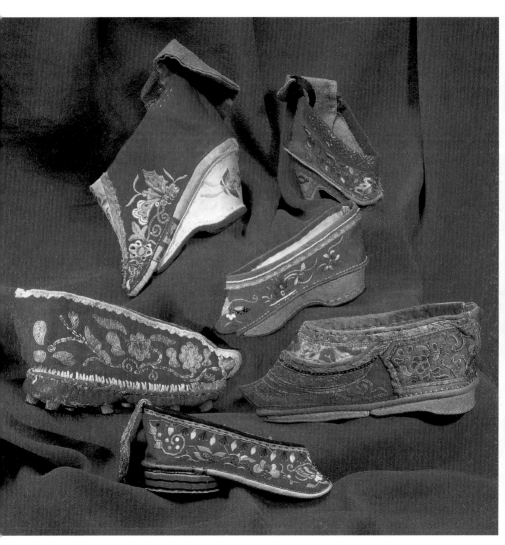

233

Cox is renowned for his quirky designs which incorporate materials such as silk, chain mesh and crucifixes into classic women's shoes. With time his designs have become more classic. In 1993, he introduced his successful 'Wannabe' loafers. These flat shoes appeal to both sexes. More recently in 2003, Patrick Cox has been designing for the French shoe house Charles Jourdan. Patrick Cox is also known for his provocative advertisement campaigns featuring the actress Sophie Dahl.

Shoe of the parish priest of Ars

International Shoe Museum, Romans

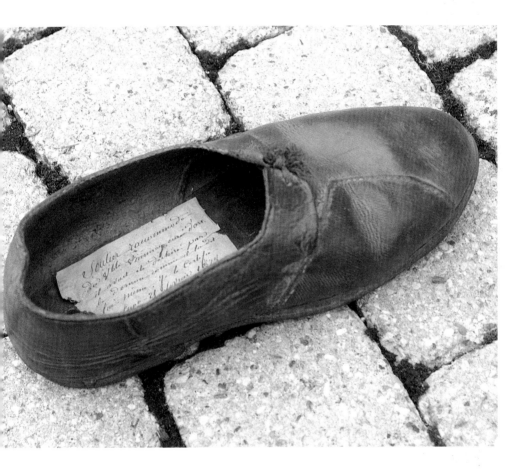

GLOSSARY

Babouche: The babouche, "slipper of coloured leather with neither quarter nor heal" (Littré), is probably of Iranian origin as proved by the Persian word PAPOUTCH (from pa, "foot" and pouchiden, "to cover").

Boot: Shoe covering the foot and part of the leg at the same time and rising to various heights.

Goethe Slippers

Bally Museum, Schönenwerd, Switzerland

Ankle boot: Woman's shoe very fashionable in winter since 1940. Strictly speaking, it is a short boot with a fur-lined interior, the fur-lining peeking out and serving as decoration.

Bottine: Small boot, of which the upper part rises above the ankle to cover the calf at various heights, fastened by laces or buttons. During the Middle Ages, bottines are called boots without soles that are slipped over the shoe like gaiters or houseaux.

Shoes of Maurice Chevalier

Derby in navy blue suede, worn at the Théâtre des Champs-Elysées at the time of his farewell to the stage
International Shoe Museum, Romans

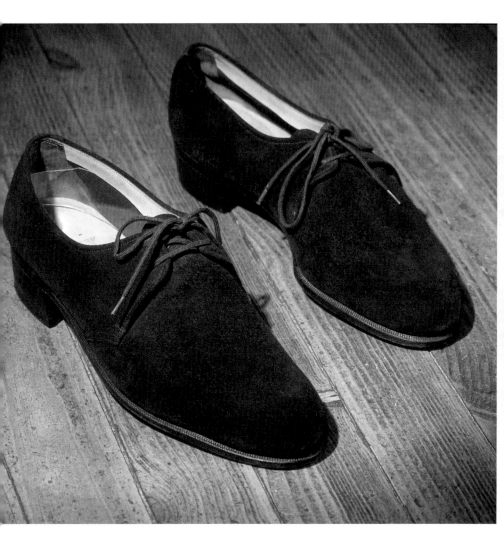

In the 19th century, from the end of the Restoration, women wear bottines, whether of fine leather or fabric with or without heal, in following the mode. One finds laced bottines and bottines with buttons, for which came the invention of the buttonhook. At the beginning of the 20th century, women wear very elegant bottines with a high upper rising to the calf. The vogue of bottines begins to disappear after the war of 1914-1918.

Shoes from the César workshop

Clog in thick brown leather
International Shoe Museum, Romans

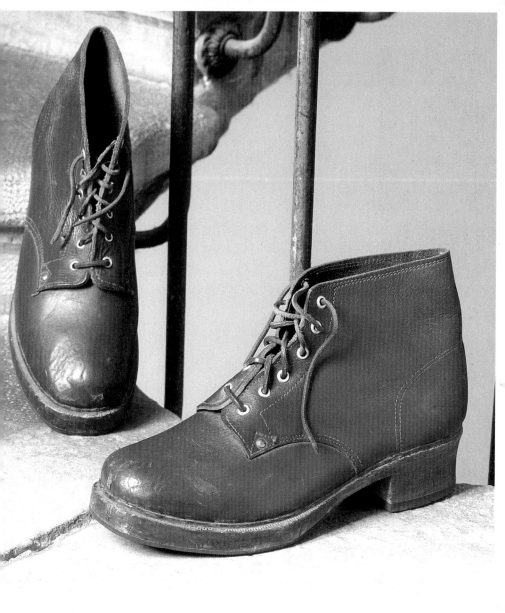

Slipper: Light and supple shoe suited to various uses: house slippers, ballet slippers, fencing slippers, bootees. Interior, removable part of a ski boot or walking shoe assuring the tight and supple contact between the foot and the outer shell of the shoe.

Men's shoes

executed by Berluti

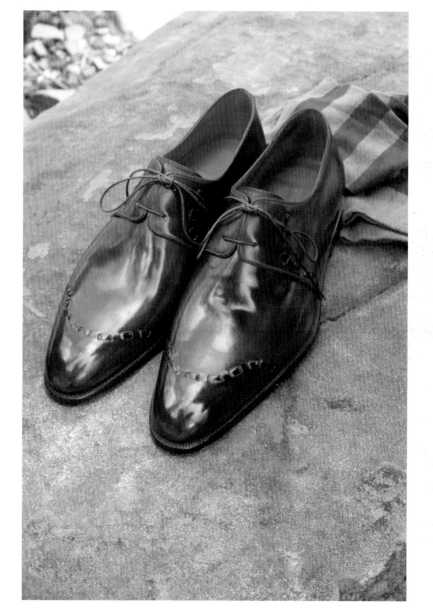

Chopine: Woman's shoe worn in Venice in the 16th century, also called "stilted mule" or "cow's foot". These strange shoes, held to the foot by ribbons, demonstrate pedestals of an excessive height reaching up to fifty-two centimeters.

Espadrille: Cloth shoe with a braided rope sole worn throughout Spain and the southern regions of France.

Princess Grace of Monaco's shoes

Beige cloth embroidered
with multicolored flowers, Louis XV heel
Exclusive model conceived by Evins and designed by Miller
International Shoe Museum, Romans

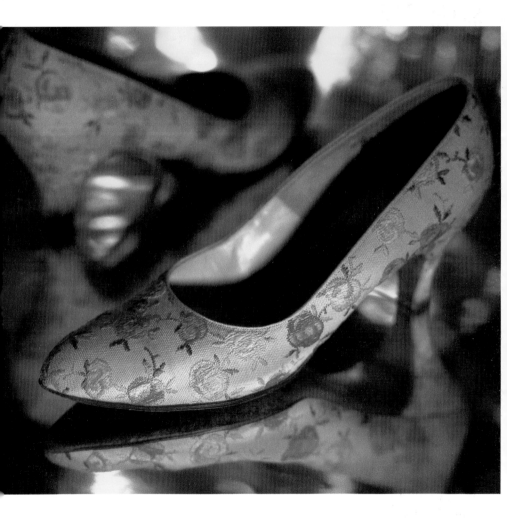

Mule: Light house shoe without quarter leaving the heel exposed.

Sandal: Worn since Egyptian, Greek and Roman antiquity, this simplified shoe is made up of a sole and straps or strips of various widths and assembled in a variety of ways, between which the foot remains visible. Several religious orders still keep with the use of sandals.

Shoe: Covering for the foot but stopping at the instep.

Mules in suede by Anne-Marie Beretta

Metal heel shaped as a crouched Titan
International Shoe Museum, Romans

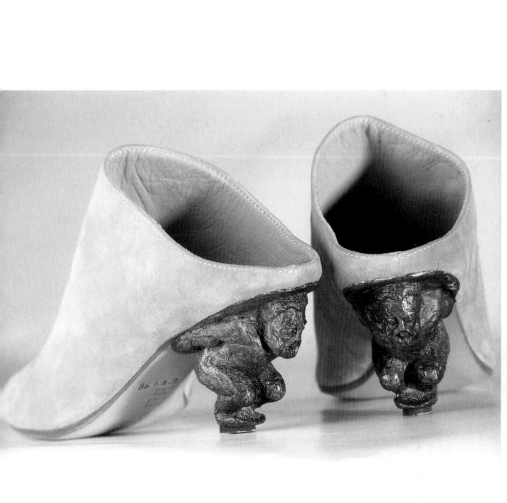

Index